POSTCARD HISTORY SERIES

Lake Erie
Ports and Boats
IN VINTAGE POSTCARDS

LAKE ERIE FACTS. This postcard might have included more facts about Lake Erie. For example, it is 9,900 square-miles in size. The sailing mileage from Buffalo to Detroit is 285 miles. Of the other Great Lakes, Superior, Huron, and Michigan are larger than Erie. Lake Ontario is smaller. Over 10 million people get their drinking water from Lake Erie. At some points it is nearly 60 miles from the U. S. to the Canadian shore.

POSTCARD HISTORY SERIES

Lake Erie Ports and Boats

IN VINTAGE POSTCARDS

Sally Sue Witten

ARCADIA

Published by Arcadia Publishing,
an imprint of Tempus Publishing, Inc.
3047 N. Lincoln Ave., Suite 410
Chicago, IL 60657

Printed in Great Britain.

Library of Congress Catalog Card Number: 2001089683

For all general information contact Arcadia Publishing at:
Telephone 843-853-2070
Fax 843-853-0044
E-Mail sales@arcadiapublishing.com

For customer service and orders:
Toll-Free 1-888-313-2665

Visit us on the internet at http://www.arcadiapublishing.com

CONTENTS

ACKNOWLEDGMENTS

Appreciation is due to all the photographers, mostly unknown, who took the pictures that graced the postcards used in this book. Special thanks goes to the Lake County Museum/Curt Teich Postcards Archives for permission to copy their cards. The Curt Teich cards used here and elsewhere contribute significantly to United States history. Special gratitude goes to Phyllis Cermak of Lakeside, Ohio for her assistance in the production of this book.

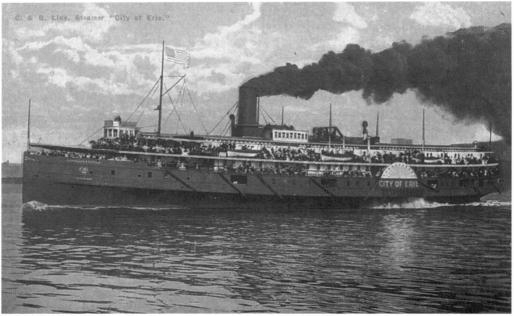

CITY OF ERIE. Built in 1897 for the Cleveland and Buffalo Line, the *City of Erie* was sometimes called "The Flyer of the Lakes" because of her speed. It was 1901 when she beat the *Tashmoo* in a race from Cleveland to Erie. She made so many trips from Cleveland to Buffalo with passengers going to Niagara Falls that she became known as the "Honeymoon Special." Her routes also included Cleveland to Cedar Point and Put-in-Bay (1914 to 1924) and Buffalo to Port Stanley

INTRODUCTION

The purpose of this book is to preserve pictures of boats and waterfront scenes at ports on both the United States and Canadian sides of Lake Erie. Over 200 pictures mostly from 1900 to 1950 are arranged to circle Lake Erie beginning at Buffalo, New York and going around the lake to Port Colborne and the Welland Canal. The illustrations are all from postcards in the author's collection.

Several changes occurred in the culture during the last decade of the 19th century and the first decade of the 20th century. For example, the United States Congress authorized the printing of private mailing cards to be mailed for 1¢ postage. Almost immediately the hobby of postcard collecting was born. Because so many early postcards were saved, pictorial histories can be compiled today.

Simultaneously with the advent of postcards, there was a surge in the industrialization and urbanization of North America. Small manufacturing operations grew into large plants. The economies of Lake Erie ports depended upon lake transportation to bring the raw materials and then to move the manufactured goods to markets. Passenger boats brought people to work in the factories from other parts of the United States and Europe. Midwest farmers depended on lake shipping to transport agricultural products. Inland economies depended on lake transportation as well. For example, a large percentage of West Virginia, southern Ohio, and Kentucky coal then and now comes to Lake Erie ports by railroad to be shipped by boat to power plants and steel mills. Iron ore from the iron ranges of Minnesota also depended upon boats for transportation.

Transformation from a predominantly rural to an industrial economy meant that more people had more time and money to take vacations. Tourism created a new demand for passenger boats on Lake Erie. Many ports developed boat building industries. Commercial fishing became a significant part of the economy at some ports.

The postcard pictures in this book capture the changing economies in communities. In addition there are pictures of the many lighthouses that were so essential to navigation before radios and radar. There are also pictures of U.S. Life Saving Service stations at a number of ports. Personnel of these stations were charged with rescuing people from boats in distress. The Life Saving Service and the U.S. Revenue Cutter Service were merged in 1915 to form the U.S. Coast Guard.

The postcard pictures capture some of the changes in the technology of loading and unloading freighters. From primitive loading and unloading operations by men with wheelbarrows, there was progress to horses and then to steam operated hoists or "whirlies." Then came Hulett unloaders and car dumpers that could tip the contents of a railroad car into a boat. Eventually self-unloading equipment was developed for installment on boats. With every new invention, freighters of larger size could be built.

Almost every community along the lake has been or is now engaged in the process of waterfront improvement. Old docks and warehouses are being removed or converted to upscale restaurants and places of entertainment. Lakefront parks are being built. State and provincial governments have taken action to preserve wetlands, beaches, and other lakeshore properties. Government regulations have also controlled pollution so that Lake Erie is cleaner at the beginning of the 21st century than it was at mid-20th century.

There is no better vacation than to take a trip around Lake Erie by auto or personal watercraft. There are a number of contemporary guidebooks for land or water travelers. Take *Lake Erie Ports and Boats* along on the trip to appreciate how things used to be. Or use the book to take a trip around the lake without ever leaving home.

One
BUFFALO

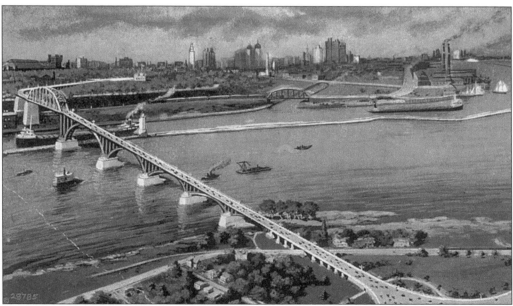

PEACE BRIDGE. The Peace Bridge linking Buffalo, New York and Fort Erie, Ontario opened in 1927 to commemorate over 100 years of peace between the United States and Canada. It was dedicated by the Prince of Wales and U.S. Vice President Charles Dawes. The view is from Fort Erie towards Buffalo.

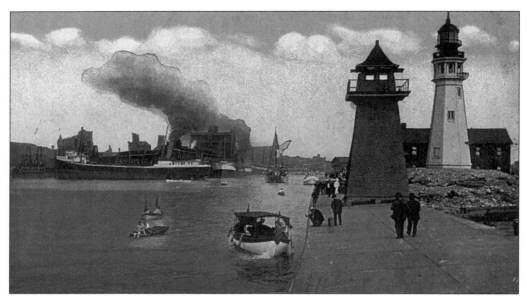

BUFFALO MAIN LIGHTHOUSE. Located at the mouth of the Buffalo River, the Buffalo Main Lighthouse at far right was built in 1833 to replace an earlier one. It is octagonal in shape and constructed with blocks of limestone.

PACKAGE FREIGHTER. The wooden package freighter has a round pilot house of the 1800s commonly called a "bird cage." The arched truss was to strengthen the center of the boat and avoid buckling if the load was not evenly distributed. While pictured next to a coal dock, this boat's cargo was probably grain.

SAIL BOATS. In the days before trucks, small sailboats carried all kinds of cargo. Smoke stacks on the boat second from left and in the second row next to the dock indicate they had engines. Those with engines might tow several of the ones which relied on wind power.

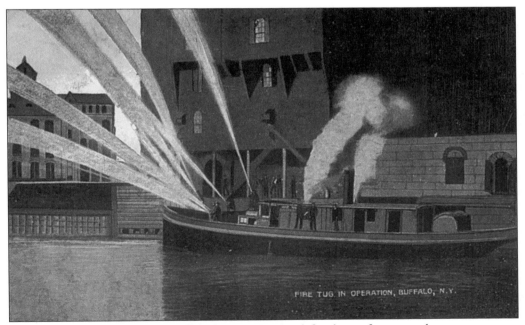

FIRE TUG. Large ports like Buffalo have maintained fire boats for more than a century to extinguish fires on both boats and dock facilities. The tug pictured here is demonstrating how its hydraulic pumps operate rather than actually fighting a fire.

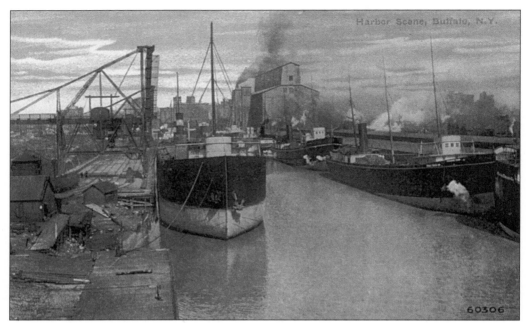

HARBOR SCENE. Coal loading equipment on the left and grain elevators on the right give a glimpse of Buffalo's major products for shipping. The *Augustus P. Wolvin* on the left was built in 1904 with an open pilot house. With a length of 506 feet and a width of 36 feet she was the largest boat on the lakes for about two years.

HARBOR SCENE. From the days of early sailing schooners, Buffalo was a major gateway to the west. Thousands of immigrants and residents of the eastern seaboard came to Buffalo to board boats destined for the upper Midwest. In this harbor scene of about 1910, Buffalo has a modest skyline.

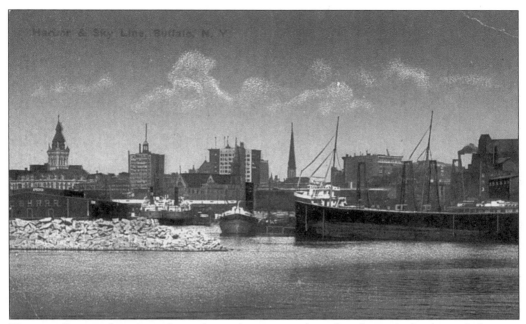

HARBOR SCENE. A variety of vessels are shown near the railroad terminal at lower left.

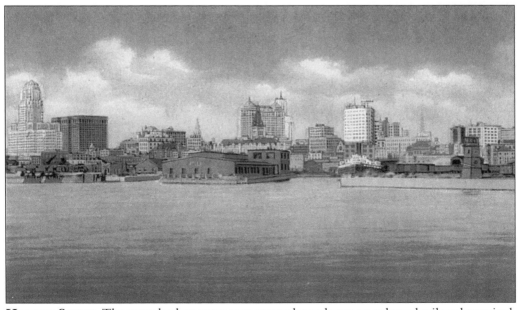

HARBOR SCENE. The same harbor scene some years later shows an enlarged railroad terminal. Some skyscrapers have appeared on the skyline.

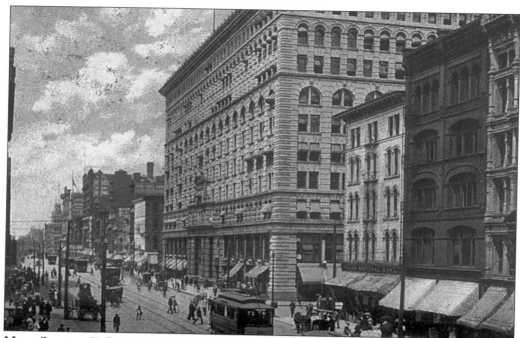

MAIN STREET. Before many automobiles began to appear, Main Street was a busy place with trolley cars and horse drawn vehicles. The Third National Bank is the shortest of the three buildings on the right. The City Bank's sign is on the top of a building farther down the block.

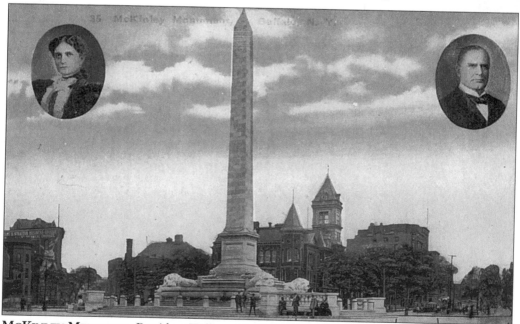

McKINLEY MEMORIAL. President William McKinley was assassinated in Buffalo in 1901 while attending the Pan American Exposition. A monument was erected to his memory in Niagara Square. Pictures of McKinley and his wife Ida Saxton McKinley are inserts on the postcard.

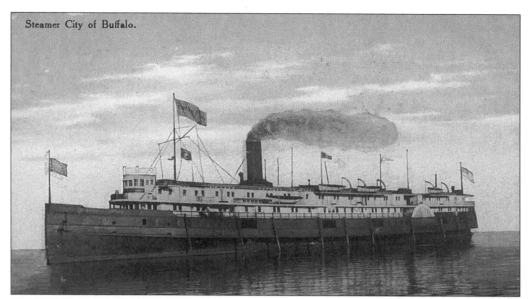

Steamer City of Buffalo.

CITY OF BUFFALO. Built in 1896 at Wyandotte, Michigan, the *City of Buffalo* was the pride of the Cleveland and Buffalo Line. Originally 314 feet in length, she was later lengthened to 356 feet. She ran from Buffalo to Cleveland and burned in 1938 at Cleveland's Ninth Street Pier during winter lay-up.

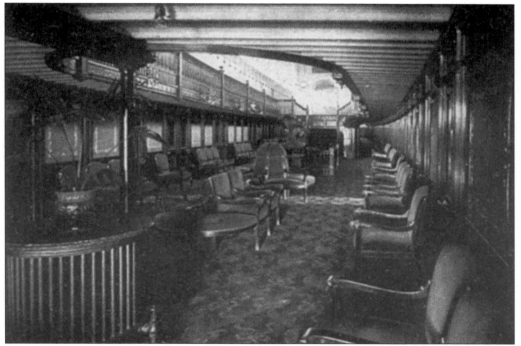

MAIN SALOON OF *City of Buffalo*. Victorian elegance was reflected in the decor of the *City of Buffalo*. Beautiful carpeting and wood paneling complemented the plush furniture of the main saloon.

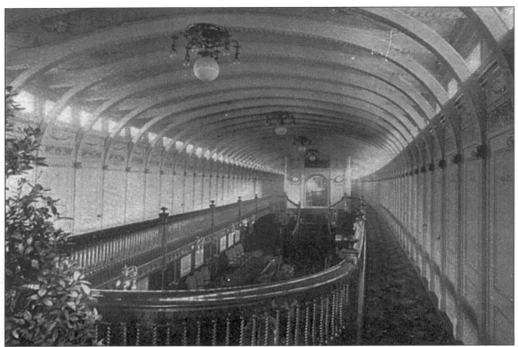

GALLERY DECK OF *City of Buffalo*. The gallery deck looked down on the main saloon. The *City of Buffalo* was one of several boats known as the "honeymoon special" because so many newly married couples went on it from Cleveland to Buffalo to visit nearby Niagara Falls.

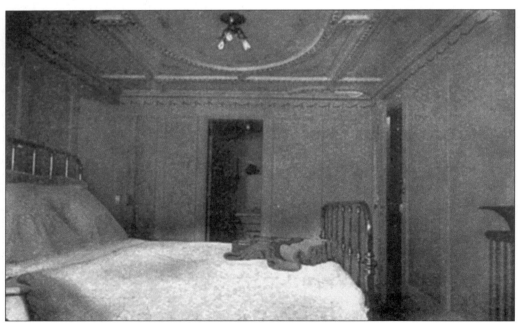

STATEROOMS OF *City of Buffalo*. Staterooms on the *City of Buffalo* were attractively decorated. No bunk beds here! The boat had electric lights as evidenced by the ceiling light fixture.

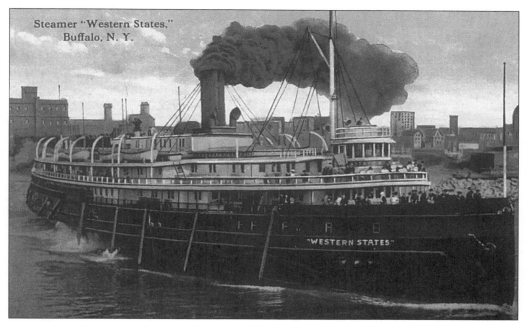

Steamer "Western States,"
Buffalo, N. Y.

WESTERN STATES. Both the *Western States* and her sister ship *Eastern States* were 362-feet long and 80-feet wide. Like all D & C Line boats, they had black hulls and smoke stacks. In addition to Detroit to Cleveland and Buffalo runs, *Western States* for some years ran Detroit to Chicago.

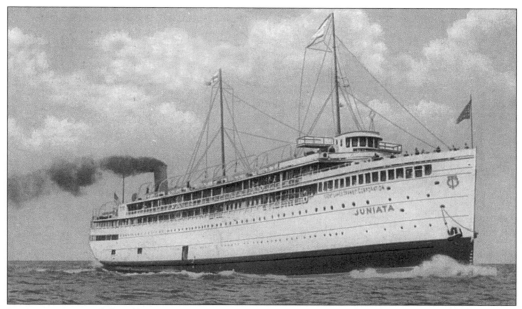

JUNIATA. Named for a Pennsylvania river, the *Juniata* was launched in Cleveland in 1904 for the Anchor Line. Described as "palatial," she provided regular service from Buffalo to Duluth. The *Juniata*'s sister ships were the *Octora* and *Tionesta*. The *Juniata* was withdrawn from service in 1937.

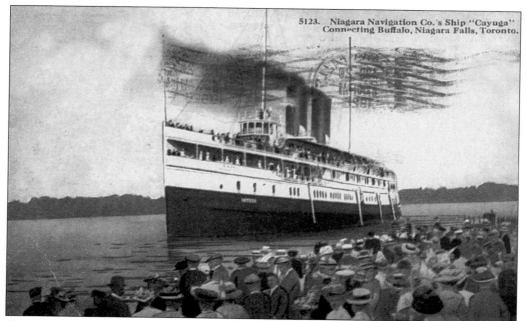

CAYUGA. Owned by the Niagara Navigation Co., a Canadian Company, the *Cayuga* carried thousands of passengers from Toronto, Ontario to Buffalo to visit Niagara Falls. This card, mailed in 1925, indicates that large hats were the proper attire for women passengers.

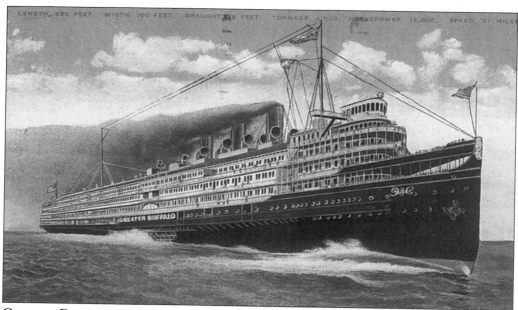

GREATER BUFFALO. Built in 1924, the *Greater Buffalo* was 536-feet long with a 96-foot beam. Her sister ship was the *Greater Detroit*. During World War II, several decks were removed and the *Greater Buffalo* was converted to an aircraft carrier training ship and renamed the *Sable*.

18

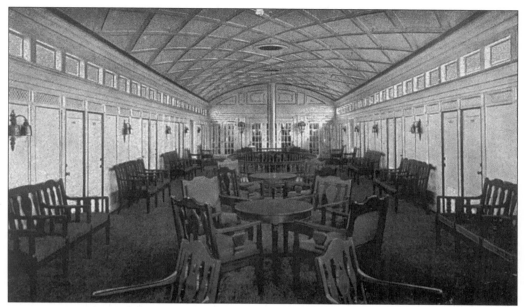

PARLOR OF GREATER BUFFALO. One of 26 parlors on the *Greater Buffalo* is pictured before its conversion. It had the capacity to carry 125 automobiles for passengers who did not want to make roundtrips.

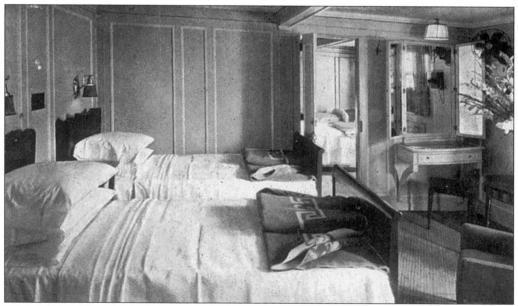

BEDROOM SUITE OF GREATER BUFFALO. The *Greater Buffalo* had a sleeping capacity for 1,700 passengers and a crew of 275. This bedroom suite was comfortably furnished with such amenities as bed lamps, a dressing table, and a vase of flowers. Overnight trips were made from Buffalo to Detroit.

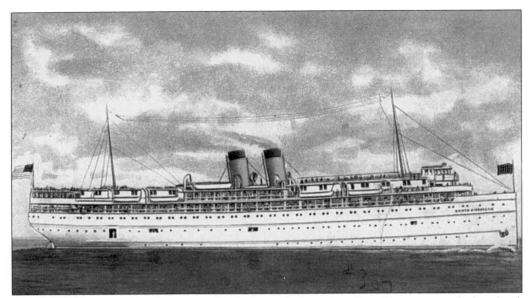

SOUTH AMERICAN. The Chicago, Duluth, and Georgian Bay Line operated the *South American* and her sister ship *North American* in the 1930s and 1940s. They were billed as "The Ocean Liners of the Lakes." Accommodating about 500 passengers in luxurious staterooms, they made excursions to all major ports on the lakes.

TUG BOAT. A large tug boat is passing under the Peace Bridge near the Black Rock Canal. Tugs of this size were used in salt water. The one pictured may have been built in a Lake Erie port and may have been headed for the Atlantic Ocean.

Two
DUNKIRK TO ERIE

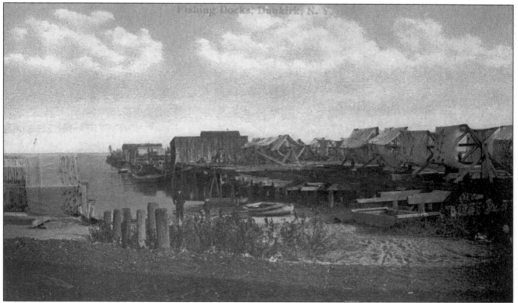

DUNKIRK'S HARBOR. Early in the 20th century, commercial fishing was one of the strengths of Dunkirk, New York's economy. Fish houses line the waterfront and fishing nets are out to dry in the right foreground.

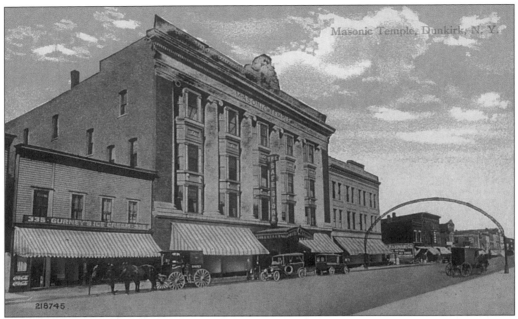

DUNKIRK BUSINESS DISTRICT. Dunkirk's downtown buildings included a handsome Masonic Temple, a Safe Store, and a hardware store. The dairy wagon is making a delivery to Gurney's Ice Cream Store. The arch across the street was an early form of street lighting.

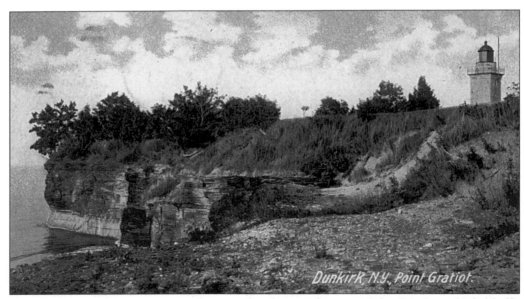

POINT GRATIOT LIGHTHOUSE. Because the shores of eastern Lake Erie have high bluffs, lighthouses were built on the bluffs to be more visible. The lighthouse for the Dunkirk harbor was erected in 1875 on a bluff at Point Gratiot replacing a light built in 1827.

22

GRAPE BELT. The grape belt extends for miles along Lake Erie in both New York and Pennsylvania. Westfield, New York has been known as the "grape juice capital of the world" for more than a century and is a center for wine making.

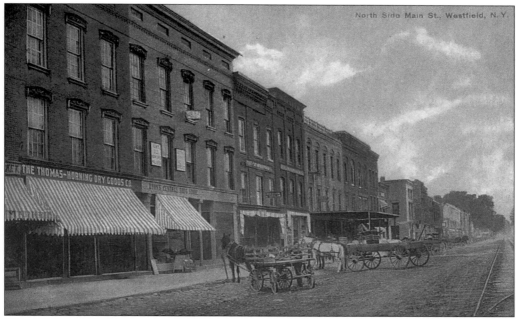

WESTFIELD'S MAIN STREET. Included among the businesses on Westfield, New York Main Street were the Thomas-Horning Dry Goods Co., Lion's Central Drug Store, and a grocery store. Notice the railroad tracks in the middle of the street.

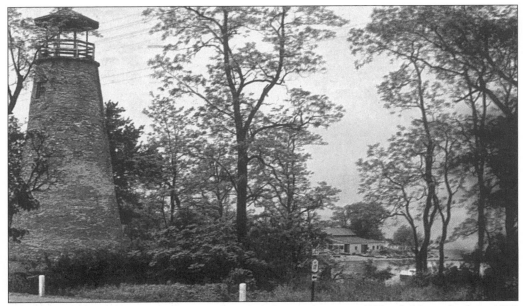

BARCELONA LIGHTHOUSE. The Barcelona lighthouse that served Westfield was built in 1828 and decommissioned in 1859. It was the only light on the Great Lakes and one of the few in the world to ever be lighted with natural gas. It is now privately owned.

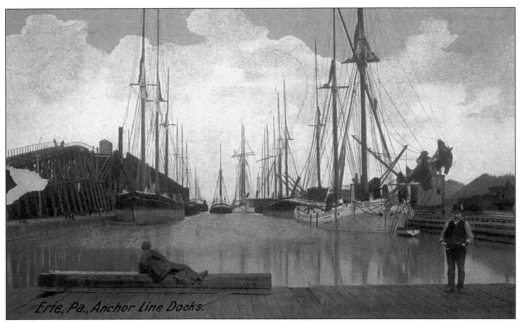

Erie, Pa., Anchor Line Docks.

DOCKS AT ERIE. Pennsylvania has just 50 miles of shoreline on Lake Erie and Erie is the chief city. The Anchor Line docks at Erie are pictured about 1909. It was a busy port as evidenced by the number of boats, piles of coal, and railroad cars.

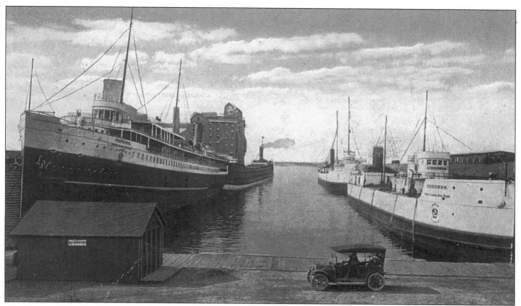

DOCKS AT ERIE. The same dock is shown about 1920 with the *Tionesta* on the left and the *Codorus* on the right. The *Tionesta*, built in 1901 with a passenger capacity of 595, ran popular cruises from Buffalo to Duluth until the 1930s. The *Codorus* was a package freighter.

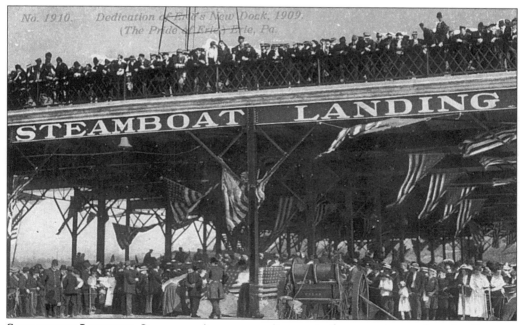

STEAMBOAT LANDING. It was a major community event when a new steamboat landing was dedicated in 1909. In 2001 the landing is home to Erie's 187-foot high Bicentennial Tower.

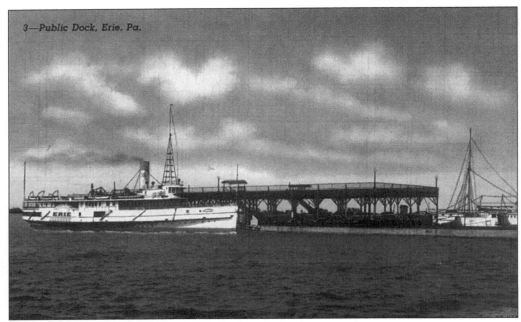

ERIE AT THE PUBLIC DOCK. The steamboat landing came to be known as the public dock. Shown is the *Erie* tied up in the late 1920s. The *Erie* had been built as the *Pennsylvania* and was later renamed the *Owana*. Designed by Frank E. Kirby, she was later destroyed by fire.

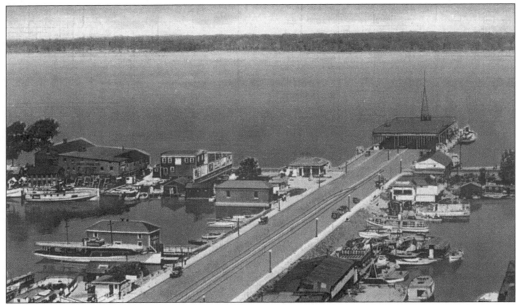

PUBLIC DOCK. In the 1930s there was an interesting array of boats on both sides of the public dock. The Presque Isle peninsula is seen at the top of the picture.

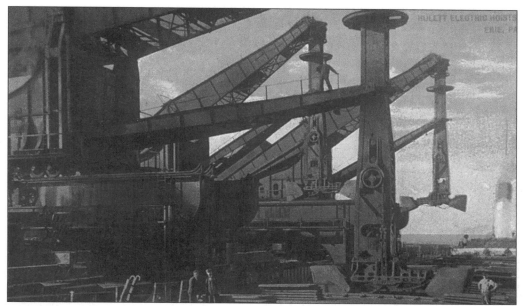

HULETTS AT ERIE. A close-up view of the Hulett Unloaders at Erie dramatizes their enormous size. With several arms scooping 17 tons out of the hold every 60 seconds, it made short work of unloading a boat.

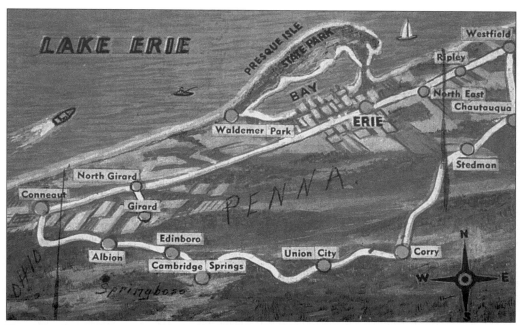

PRESQUE ISLE. A long curving peninsula known a Presque Isle protects the mainland docks at Erie. Entrance to the Bay, near top right, is very narrow. The Presque Isle Bay provided a protected place to build the boats used by U.S. forces during the battle of Lake Erie in the War of 1812.

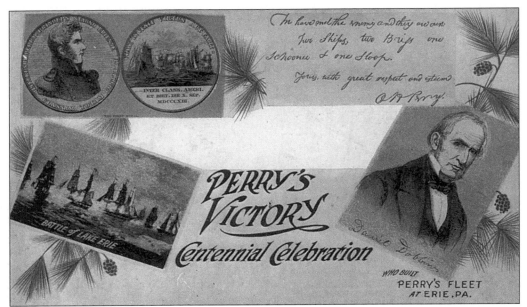

PERRY'S VICTORY CELEBRATION. In 1913 Erie honored the centennial of the Battle of Lake Erie. Oliver Hazard Perry, commander of the U.S. fleet is in the insert at top left. The larger picture at lower left is of Daniel Dobbins, who directed construction at Presque Isle Bay of 6 of the 11 U.S. naval ships used in the battle.

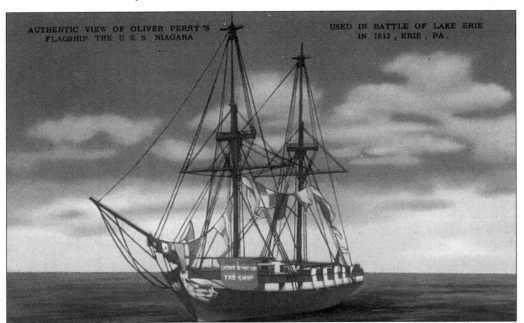

BRIG NIAGARA. After the Battle of Lake Erie, Perry's boats returned to Erie from Put-in-Bay. To protect them from the weather, they were sunk in Presque Isle Bay. The *Niagara*, Perry's flagship after the *Lawrence* was disabled, was raised in 1912 and has undergone several restorations. Now stationed at the Erie Maritime Museum, she now occasionally sails to other ports.

LIFE SAVING STATION. The boat house and boat launching ramp are towards the left in this picture of the life saving station at Erie. The person in charge of a station was known as the keeper, and members of the crew were either surfmen or oarsmen.

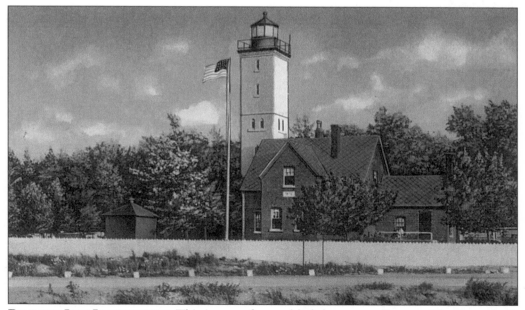

PRESQUE ISLE LIGHTHOUSE. This is one of several lighthouses on Presque Isle. It was built in 1872. With an automated light, the keeper's house is no longer needed and has become a private residence.

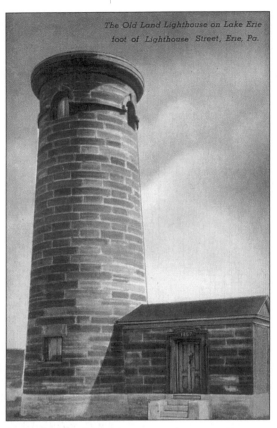

The Old Land Lighthouse on Lake Erie
foot of Lighthouse Street, Erie, Pa.

ERIE'S LAND LIGHTHOUSE. The third of Erie's lighthouses to be built on a high cliff on the mainland was built in 1867. It was decommissioned in 1899. Made of blocks of sandstone, it is still being preserved.

ERIE LIGHTHOUSE. Although records have been destroyed, it is believed that Erie had the first lighthouse on Lake Erie in the early 1800s. This light is considered to be a direct descendant of that early light.

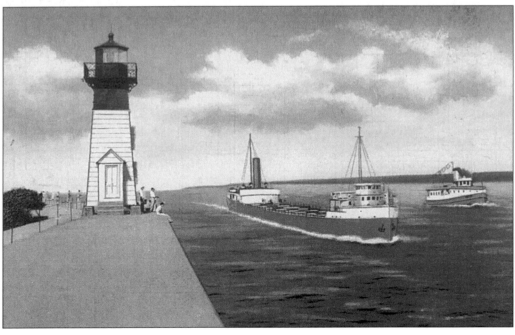

Three
CONNEAUT TO
FAIRPORT HARBOR

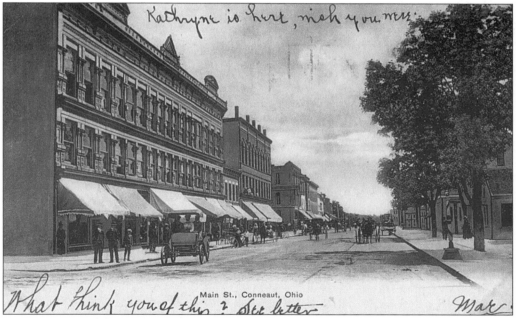

CONNEAUT MAIN STREET. Just over the state line from Pennsylvania, Conneaut, Ohio had an attractive Main Street at the turn of the century. Agricultural products, grain, lumber, and coal were shipped in quantity from Conneaut. The importance of rail transportation in its history is reflected in a railroad museum today.

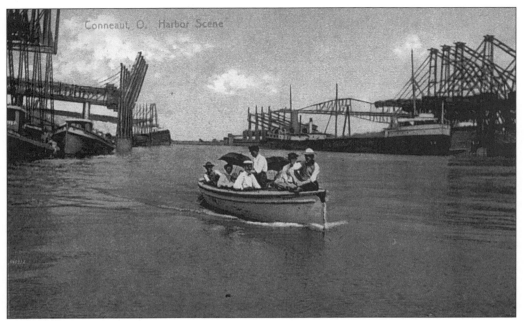

CONNEAUT HARBOR. Mailed in 1908, this postcard features a motorized recreational craft. Several freighters are being loaded and unloaded.

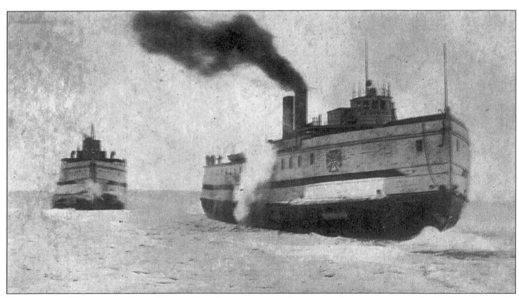

BREAKING THROUGH ICE. There is often a temptation to make one more trip before ice ends the shipping season. Here the *City of Sandusky* and another boat are breaking through the ice to enter the Conneaut harbor.

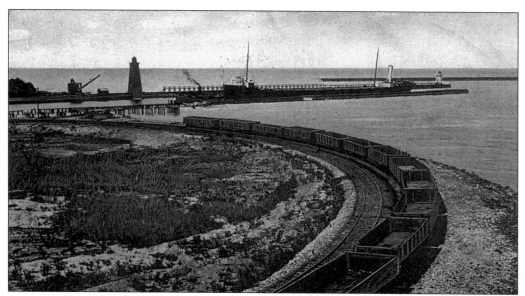

CONNEAUT HARBOR. Conneaut harbor has been an important port for receiving iron ore destined for steel mills at Youngstown, Ohio and Pittsburgh, Pennsylvania. Ore boats returned to the upper lakes with coal. Note the lighthouses. This card was mailed in 1909.

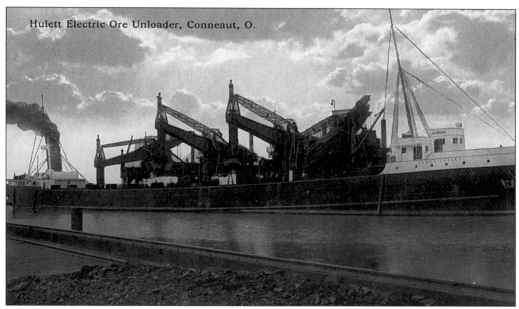

Hulett Electric Ore Unloader, Conneaut, O.

HULETT UNLOADERS. George Hulett, a native of Conneaut, made a major contribution to shipping when he invented the Hulett unloaders. They were first installed in Conneaut in 1899. Here the *James Gayley* is being unloaded. The clamshell buckets on huge electric arms could scoop ore out of holds in just a matter of hours, instead of what usually took days. Today one bucket and arm are preserved outside the marine museum in Ashtabula.

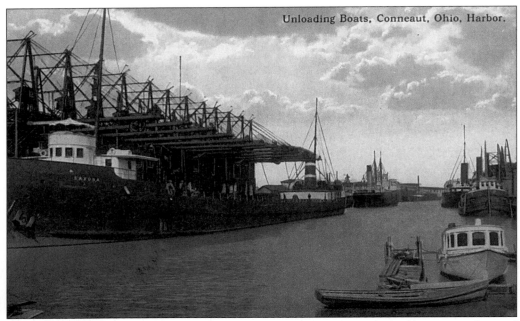

Unloading Boats, Conneaut, Ohio, Harbor.

UNLOADING BOATS. The *Saxona* is being unloaded at Conneaut. She had been one of several dozen boats caught in the great storm of November 1913. The *Saxona* went aground in the St. Clair River but was able to free herself without serious damage.

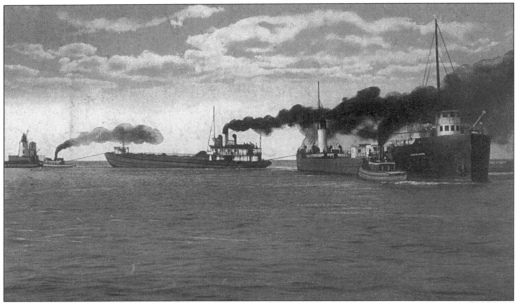

CONNEAUT HARBOR. About the time of World War I, the Conneaut harbor is pictured with an old lighthouse on the left. A whaleback freighter is in the center with the *John W. Gates* and a tug on the right. The two small houses located mid-ship on the *Gates* were crew quarters.

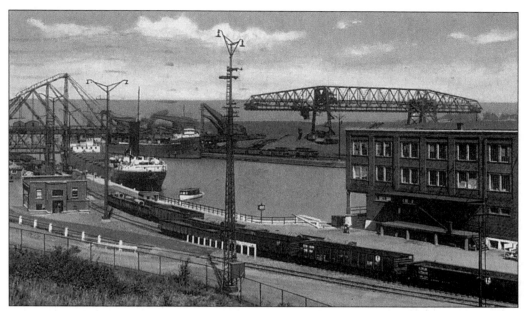

ORE BRIDGE. The apparatus at upper right is known as an ore bridge. Ore in buckets suspended from the bridge could be moved to be dumped on ore piles to await later shipment by railroad.

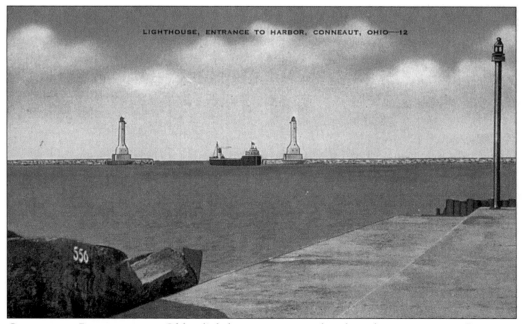

CONNEAUT LIGHTHOUSE. Older lighthouses were replaced at the entrance to Conneaut Harbor by new ones. The art deco style is similar to the one at Huron, Ohio.

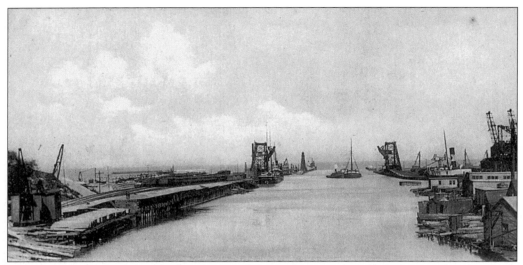

ASHTABULA HARBOR. At the beginning of the 20th century, Ashtabula was already a busy port. Its loading and unloading equipment would become more sophisticated in a few years. The lumber at lower left was one of the products being handled. The steam-powered hoists next to the lumber could pick up a load of lumber and whirl around to put it in a freight car.

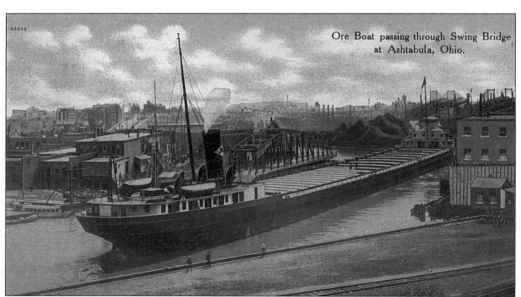

Ore Boat passing through Swing Bridge at Ashtabula, Ohio.

ORE BOAT. In this postcard mailed in 1909, an ore boat is shown negotiating the sharp turns in the Ashtabula River. The swing bridge at left center is open to let the boat pass. The ore boat would be filled with coal from the piles near the center of the picture for the return trip.

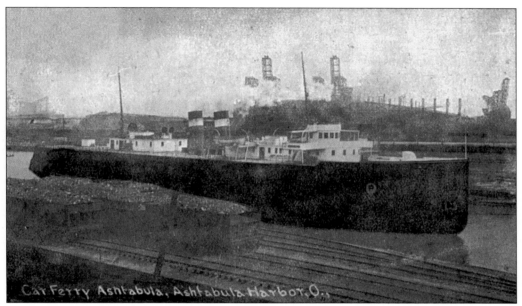

CARFERRY ASHTABULA. The *Ashtabula* was built at St. Clair, Michigan in 1906. She was 350 feet long and 56 feet wide. She could be loaded with railroad cars of coal and take them to ports such as Port Burwell, Ontario and Cleveland where the cars could be unloaded to railroad tracks. She sank near Port Burwell in 1958 after a collision with the *Ben Morrell*, and when raised, had to be scrapped.

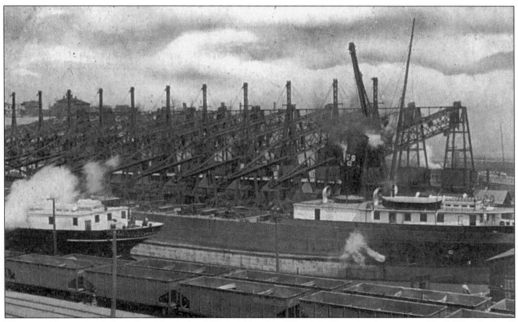

HANNA DOCKS. A freighter is at the Hanna Docks. The loading equipment called "fast hoists" was another technological improvement that shortened the time boats were required to be in port.

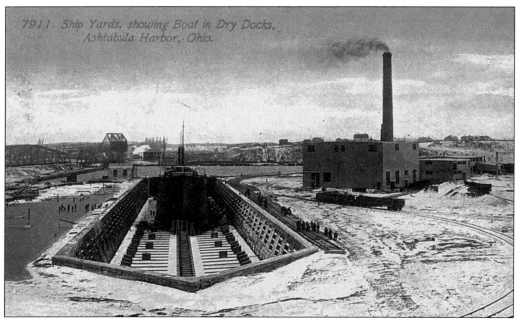

7911. Ship Yards, showing Boat in Dry Docks, Ashtabula Harbor, Ohio.

SHIP YARDS. With snow on the ground, a vessel is shown in dry dock. Possible repairs were delayed until the lake had frozen and the shipping season had been suspended. In the late 19th century it was said that Ashtabula had more bars than any port in the world except Singapore.

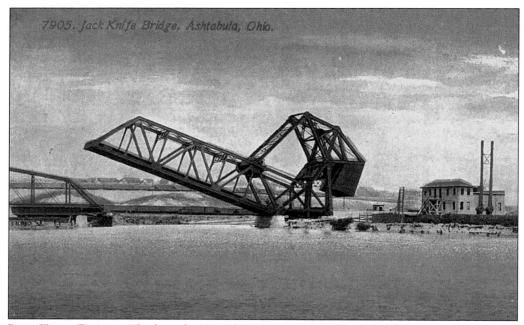

7905. Jack Knife Bridge, Ashtabula, Ohio.

JACK KNIFE BRIDGE. The bascule-type lift bridge, sometimes called the jack knife bridge, was built over the Ashtabula River in 1925. It can be raised to almost a vertical position so that tall boats can pass under it. The bridge was rehabilitated in 1986, and is still in use in the 21st century.

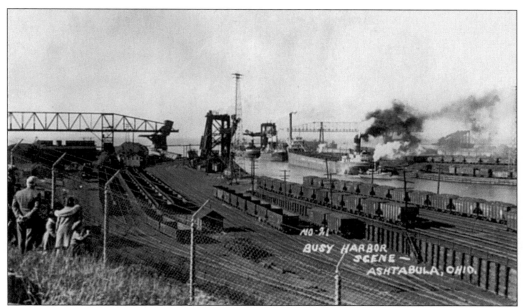

RAILROAD YARDS AND HARBOR. The variety of activities at the railroad yards and harbor have constantly drawn both old and young onlookers. Today a gracefully arched conveyor system transports coal from one side of the river to another.

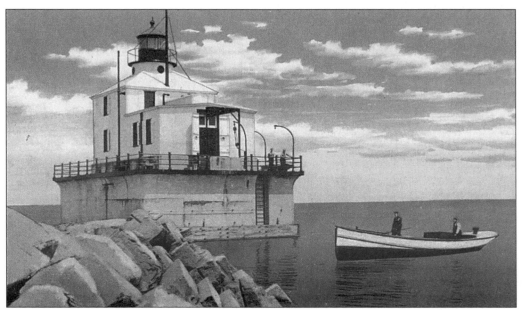

ASHTABULA LIGHTHOUSE. The first Ashtabula lighthouse was built in 1836. The one pictured is the third light built in 1905. It is accessible only by boat.

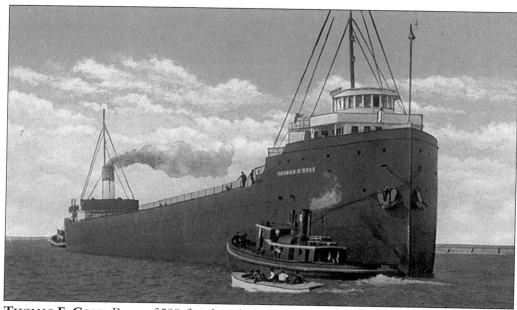

THOMAS F. COLE. Boats of 500-foot length did not dominate the lake very long before 600-footers began to appear. Built in 1907, the *Thomas F. Cole* was 600-feet long and 58-feet wide. The *Cole* brought iron ore from the upper lakes to Lake Erie ports so that plants could make war equipment for both World War I and World War II.

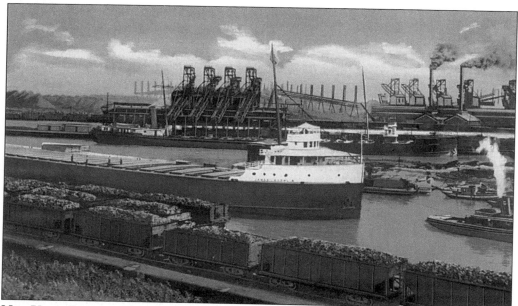

NEW YORK CENTRAL DOCKS. Piles of iron ore on one side of the river and railroad cars on both sides meant that there was around the clock activity at the New York Central docks. The freighter *James Laughlin*, owned by the Jones and Laughlin Steel Co., is in the center of the picture.

FAIRPORT HARBOR LIGHTHOUSE.
Fairport Harbor, a few miles west of
Ashtabula on the Grand River, served as
a port for Painesville, Ohio. The first
Fairport Harbor Lighthouse is shown
here in an 1859 picture from the
National Archives. It was built in 1825
and decommissioned in 1859. It was
replaced in 1875, and then that one was
decommissioned in 1925. It is now part
of a marine museum.

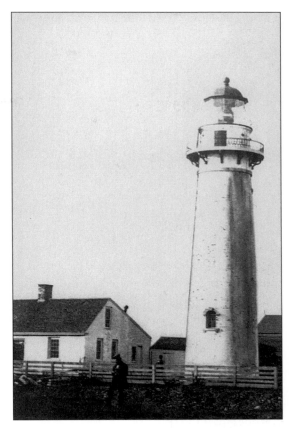

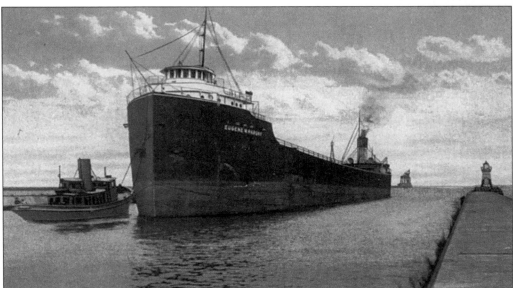

EUGENE W. PARENT. Fairport Harbor's Breakwater Lighthouse is seen in the distance with
this picture of the ore boat *Eugene W. Parent*. A tug is providing assistance to the *Parent*.

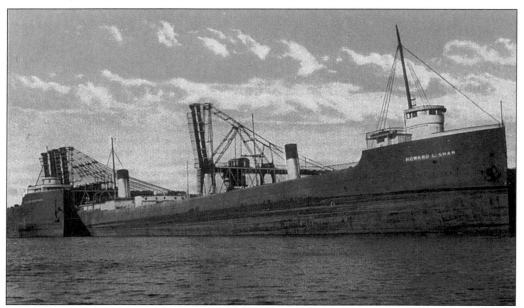

HOWARD L. SHAW. The *Howard L. Shaw* is shown at dock at Fairport Harbor. It was a Canadian boat built in 1900. Commercial fishing was once a major activity in Fairport Harbor. It is also known for shipping salt from a local salt mine.

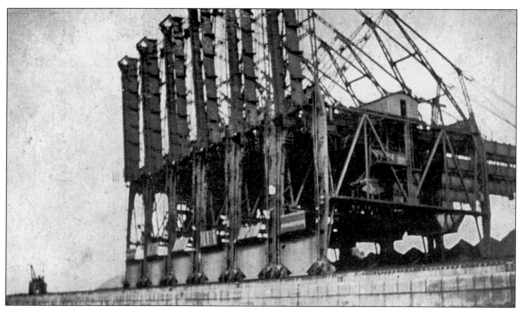

ORE DOCKS AT FAIRPORT HARBOR. The hoists shown here were late-19th and early-20th century equipment. They had less capacity and speed than Hulett unloaders.

Four

CLEVELAND

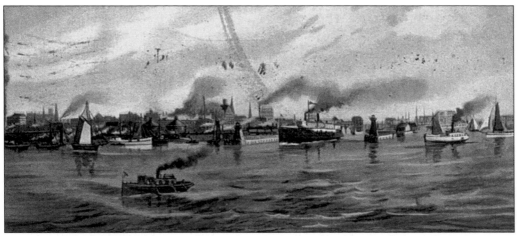

ENTRANCE TO HARBOR. In the 1890s Cleveland was already industrialized. Sailing vessels shared the entrance to the harbor with steamboats. Cleveland had been a major port at least as early as 1832 when it was connected to the Ohio River by the Ohio and Erie Canal. At the time of this picture railroads had replaced the canals.

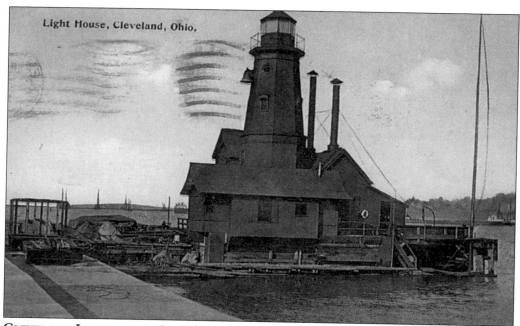

Light House, Cleveland, Ohio.

CLEVELAND LIGHTHOUSE. An early Cleveland Lighthouse is pictured. It was replaced by the East Pierhead Light built in 1910 and the West Pierhead Light built in 1911. This space was enlarged to become the site for the life saving station.

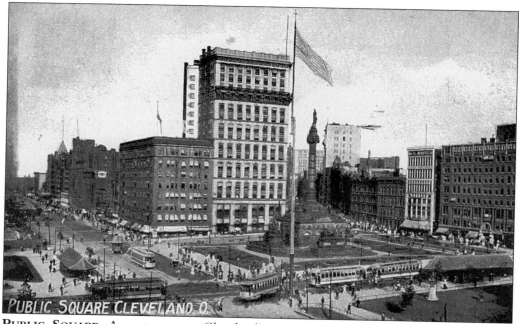

PUBLIC SQUARE CLEVELAND, O.

PUBLIC SQUARE. A century ago, Cleveland's ground transportation was dominated by trolleys. Public Square was the heart of the retail and office district. The monument was erected to honor those who had served in the Civil War.

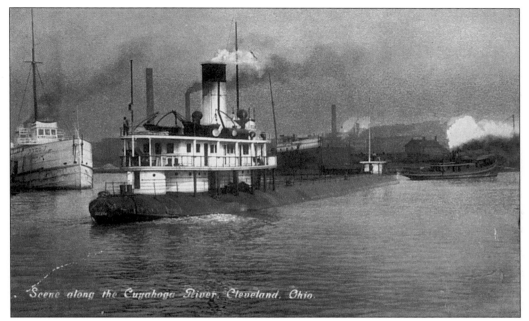

Scene along the Cuyahoga River, Cleveland, Ohio.

SAMUEL MATHER. Named for a prominent industrialist in the iron ore shipping trade, the whaleback *Samuel Mather* is pictured in the Cuyahoga River. Built in 1892, the *Samuel Mather* was 380 feet long. With a later name change to the *Clifton*, this boat disappeared in a storm on Lake Huron in 1924, losing all of the crew. As loading equipment improved, whalebacks became obsolete.

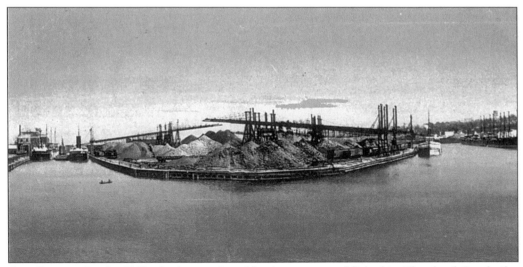

ORE DOCKS. By the 1890s the iron and steel business was established in Cleveland. Stockpiles of iron ore were kept on the Cuyahoga River or docks. The light colored piles were limestone used for flux in the steel furnaces.

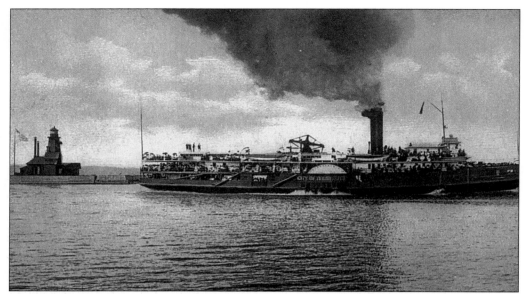

CITY OF THE STRAIGHTS. Owned by the Detroit and Cleveland Navigation Line, the *City of the Straights* was built about the same time as the *State of Ohio*. On this postcard mailed in 1908, she is seen passing the old Cleveland Lighthouse.

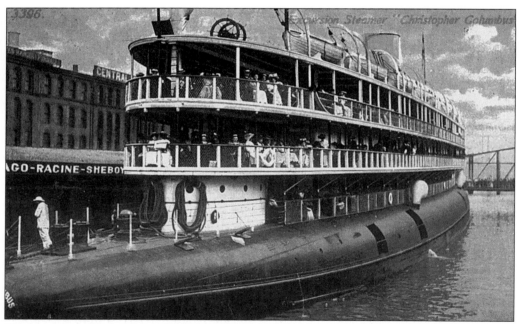

CHRISTOPHER COLUMBUS. Built in 1892 the *Christopher Columbus* was the only whaleback built to carry passengers. Her unique appearance made her a passenger favorite and she carried tens of thousands of people. While usually running out of Chicago on the upper lakes, she made excursions to Cleveland and other Lake Erie ports until 1936.

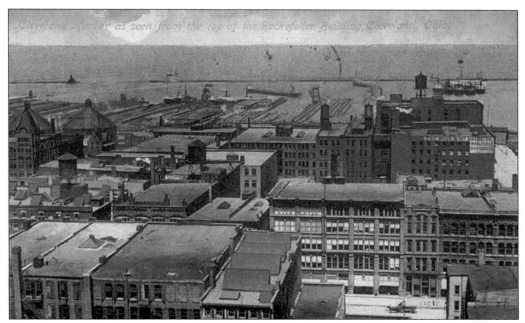

LAKEFRONT VIEW. Cleveland had docks both on the Cuyahoga River and on the lakefront. This is a lakefront view taken from the top of the Rockefeller Building. Having made a fortune establishing the Standard Oil Co., Clevelander John D. Rockefeller had the building built in 1905.

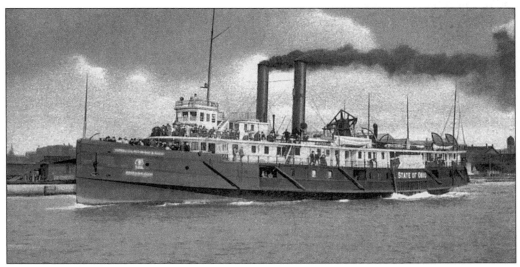

STATE OF OHIO. The D. & C. Navigation Co. operated the side wheeler *State of Ohio* on the Toledo, Put-in-Bay, and Cedar Point route for a number of years. Like other boats of the era, she carried freight as well as passengers. She burned at the Ninth Street dock while being readied for the 1924 season. Her hull was salvaged and used as a sand barge.

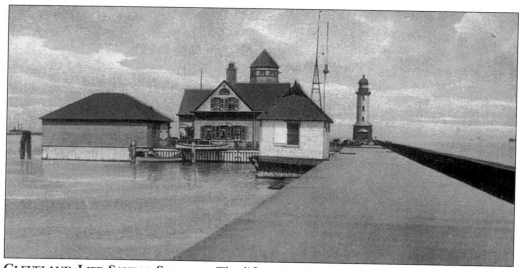

CLEVELAND LIFE SAVING STATION. The life saving station was as highly regarded for its services to boaters in its day as the U. S. Coast Guard has been since 1915. The conical West Pier Light made of steel is seen just beyond the life saving station.

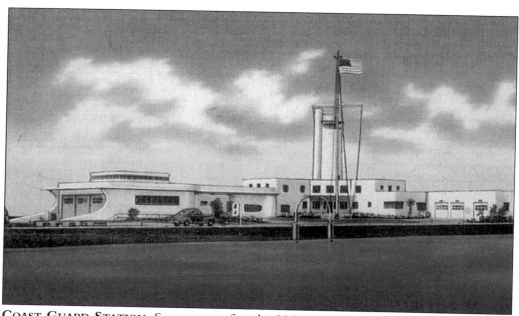

COAST GUARD STATION. Some years after the U.S. Coast Guard was established, a new Coast Guard station near the mouth of the Cuyahoga River replaced the old life saving station.

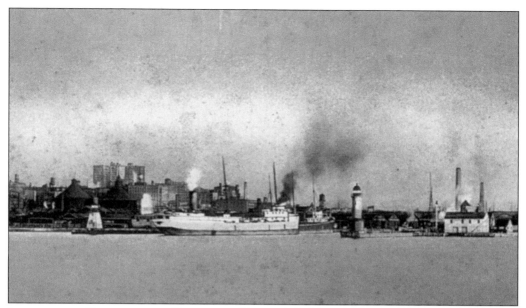

LIGHTHOUSE ENTRANCE TO CUYAHOGA RIVER. A freighter is shown entering the Cuyahoga River between the two lighthouses. The Rockefeller Building is the tall building on the left at the top of the bank.

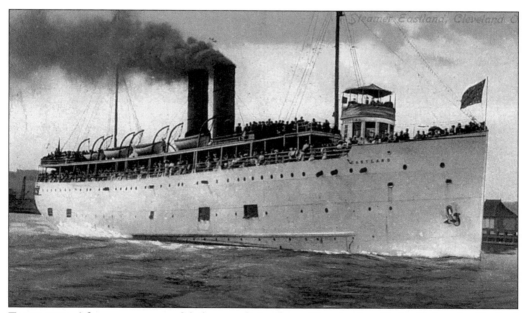

EASTLAND. After some years of daily roundtrips from Cleveland to Cedar Point, the *Eastland* was sold to Chicago owners. In 1915, after having been boarded by 2,500 people, the *Eastland* rolled over at dock in Chicago, claiming 835 lives. The *Eastland* was raised, renamed the *U.S.S. Wilmette*, and used as a naval reserve training ship.

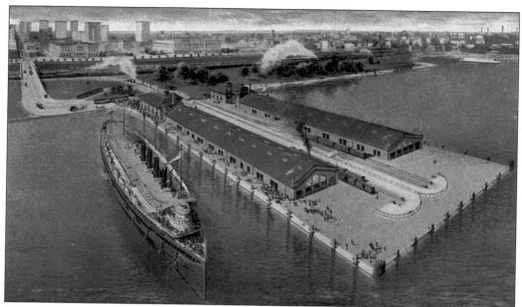

NINTH STREET PIER. About 1915 a new pier was built at East Ninth Street. Both the C&B and D&C Lines moved their passenger service here from docks on the Cuyahoga River. Railroad tracks were extended to the pier. The *Seeandbee* is leaving the pier. After most passenger service ended in the 1930s, Captain Frank's, a popular restaurant, was on the pier.

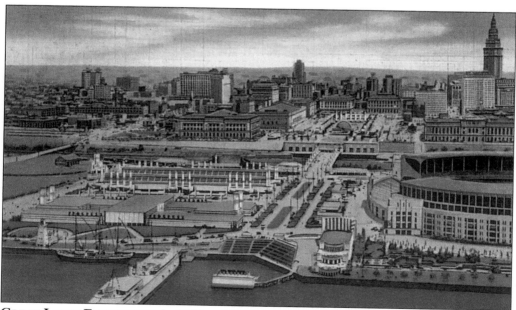

GREAT LAKES EXPOSITION. In 1936 and 1937 the Great Lakes Exposition brought crowds to the lakefront to see various exhibits. The small boat at lower left is the ship Admiral Byrd took to the South Pole. The bleachers at lower center were for an aquacade show. The Terminal Tower is at upper right and the stadium at lower right.

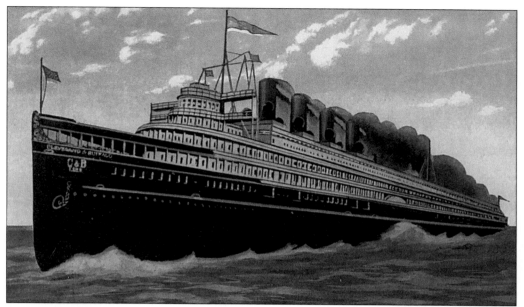

SEEANDBEE. The C&B Line's great ship the *Seeandbee*, launched in 1912, was 500-feet long and 98.6-feet wide with 500 staterooms and 24 parlors. During World War II, this grand floating hotel had upper decks removed and was converted to an aircraft carrier for training pilots based at Chicago. It was renamed the *Wolverine*.

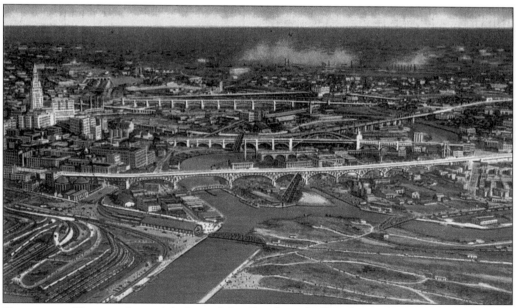

CUYAHOGA VALLEY. An aerial view of the Cuyahoga Valley shows the meanderings of the river with its many bridges and industries. The tall building at far left is the Terminal Tower completed in 1927. The center of a commercial complex, it included a hotel, department store, railroad station, offices, shops, and restaurants.

ENTRANCE TO CUYAHOGA RIVER. This view was photographed after completion of the Terminal Tower, the large building at left center. The docks, warehouses, and office buildings at the bottom of the picture are known today as "the flats." The buildings have been converted into restaurants, bars, and shops where people go for trendy entertainment.

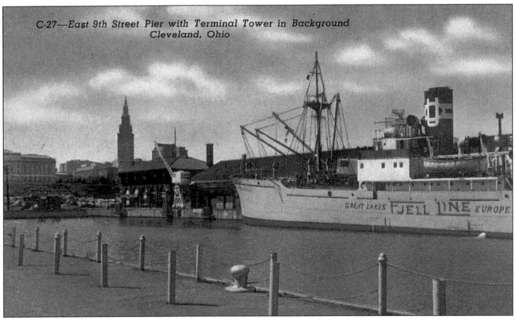

C-27—East 9th Street Pier with Terminal Tower in Background
Cleveland, Ohio

GREAT LAKES FJELL LINE EUROPE

OCEAN SHIPS. Following World War II, improvements were made to the St. Lawrence Seaway to permit the passage of larger ships. This made Lake Erie and other Great Lakes an international waterway. Ocean-going boats from around the world now dock at Cleveland and larger lake ports.

Five
LORAIN TO HURON

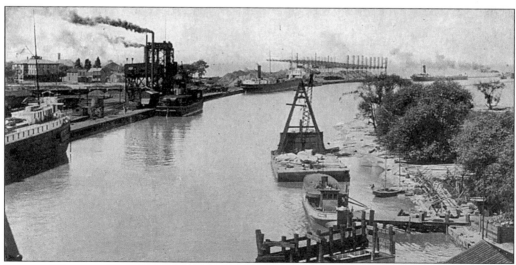

LORAIN HARBOR. The Black River provided an excellent harbor for Lorain. This 1906 picture shows a variety of vessels including a freighter, tug, dredging equipment, and a small sailboat. For decades Lorain was known for its steel mills and boat building. Today's emphasis is on marinas for pleasure boats and tourism.

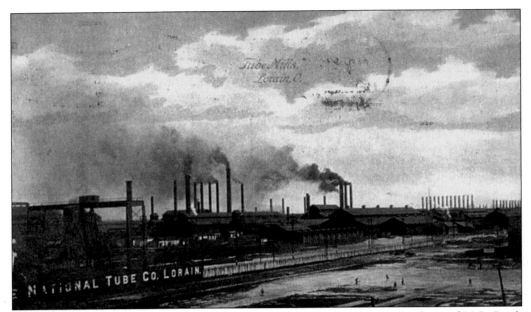

NATIONAL TUBE CO. In the early 1900s the National Tube Co., a subsidiary of U.S. Steel, began operations at Lorain. It was at a time when black smoke was considered a sign of full employment rather than air pollution. Not long before it went out of business in the 1970s, the company employed 10,000 people.

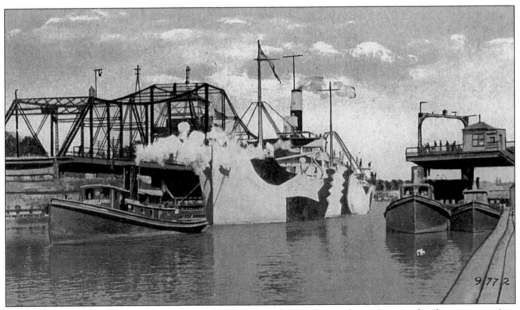

BOAT BUILDING. During both World War I and II, boatyards at Lorain built ocean-going ships. Sometimes known as "salties" or as Welland Canalers, they were of small enough dimensions to reach the Atlantic by way of the Welland Canal and St. Lawrence River. The salty being towed in this picture was painted in camouflage for wartime duty in World War I.

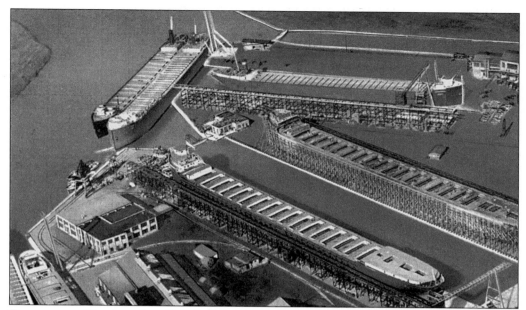

BOATYARDS. The American Ship Building Co. was a leading Lorain industry for 80 years after it opened in 1899. It built a variety of boats including passenger boats, freighters, railroad car ferries, tugs, barges, Welland Canalers, frigates, submarine chasers, and self unloaders. Old timers can still remember the day in 1944 when the frigate *U.S.S. Loraine* sailed away to war.

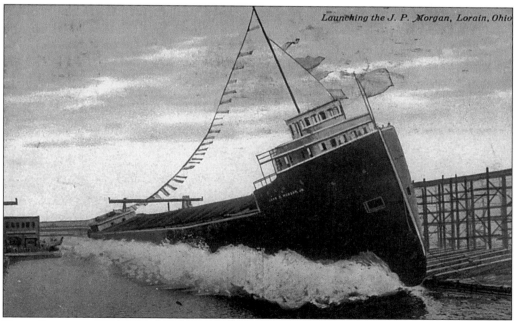

Launching the J. P. Morgan, Lorain, Ohio

BOAT LAUNCHING. The *J.P. Morgan Jr.* was launched at Lorain about 1910. She was one of many boats named for ship owners or successful industrialists.

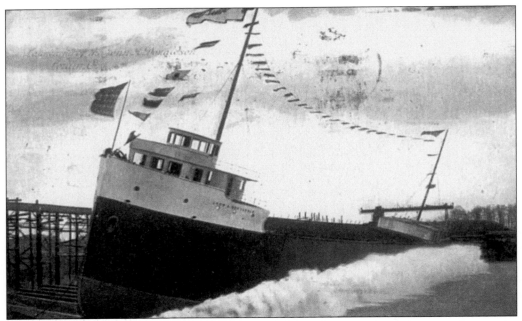

BOAT LAUNCHING. The *John M. Donaldson* came down the ways about the same time as the *J.P. Morgan Jr.* Early on, almost every port on the lake had boat building facilities, which have now passed into history.

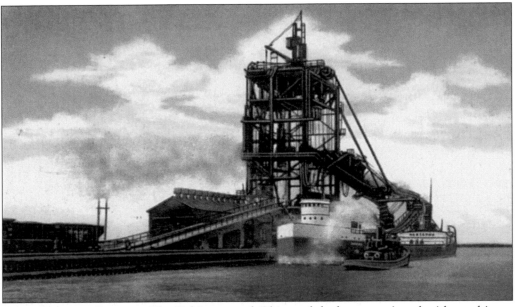

COAL DOCK AT LORAIN. The Baltimore and Ohio coal dock was equipped with machinery capable of dumping railroad cars of coal into a freighter at the rate of about one car per minute.

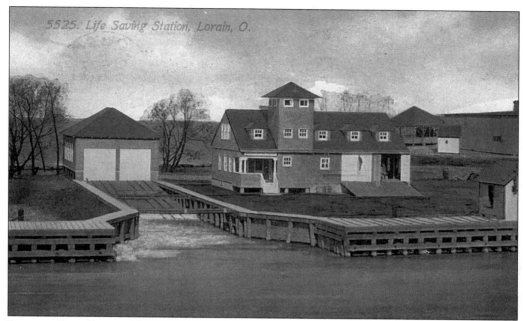

LORAIN LIFE SAVING STATION. At the mouth of the Black River, the Lorain Life Saving station had easy access to the lake. Two boats could be launched simultaneously down the incline from the boat house. From the small tower on the building, a lookout could scan both the lake and the river.

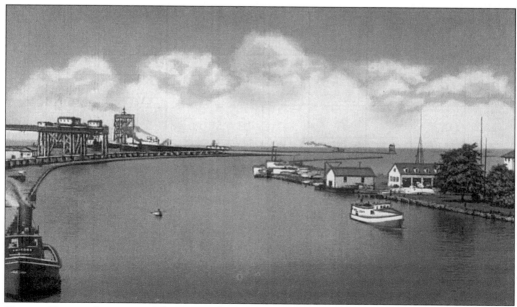

COAST GUARD STATION. After 1915, the Life Saving station became the Coast Guard station. Some additions were made to accommodate more boats.

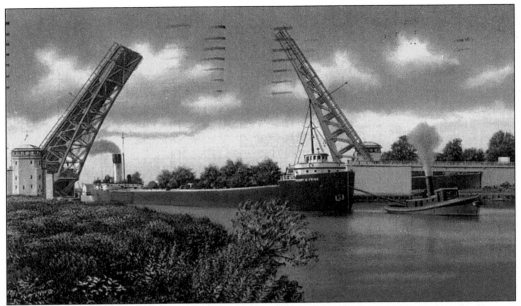

ERIE AVENUE BRIDGE. When the Erie Avenue Bridge was built in 1940, it was the longest bascule type bridge in the world. It had operating advantages over the old swing bridges that had been built decades earlier in some ports.

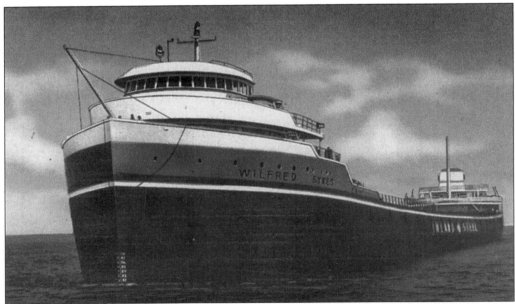

WILFRED SYKES. Built in Lorain in 1949, the *Wilfred Sykes* was 678-feet long and 70-feet wide. She was the longest ore carrier when built and kept that record until 1,000 footers began to be built in the 1970s. The *Sykes* has spent most of her time on the upper lakes. She has celebrated her 50th anniversary and is still sailing, along with the addition of self unloading equipment.

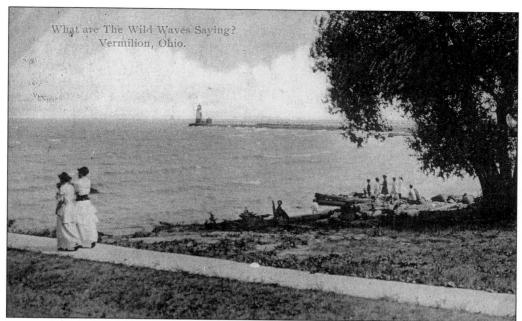

What are The Wild Waves Saying?
Vermilion, Ohio.

VERMILION LIGHTHOUSE. Seen in the distance, the Vermilion Lighthouse was built in 1877. When wooden schooners dominated the lake, Vermilion was known for its boat building. But as boats became larger, the Vermilion River was too shallow to accommodate them. Commercial fishing became Vermilion's chief industry. A replica of this lighthouse is now on the grounds of the Inland Seas Museum.

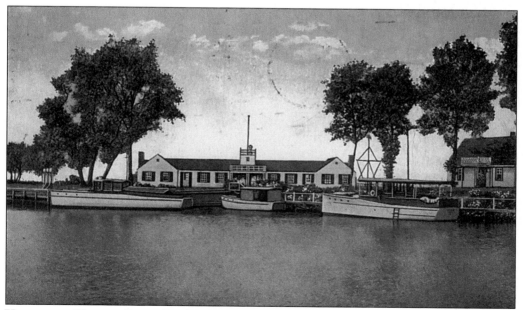

VERMILION YACHT CLUB. In the 1930s, marshland adjacent to the Vermilion River was drained and a series of lagoons were built. Today the river and lagoons are home to many marinas and private docks. The Yacht Club was one of the early attractions for pleasure boaters.

VERMILION LAGOONS. As interest in pleasure boating grew, the lagoons became popular for private docks and marinas. Today Vermilion's chief industry is tourism. The old wooden cruisers pictured here have been replaced by fiberglass ones and the need for marinas has grown.

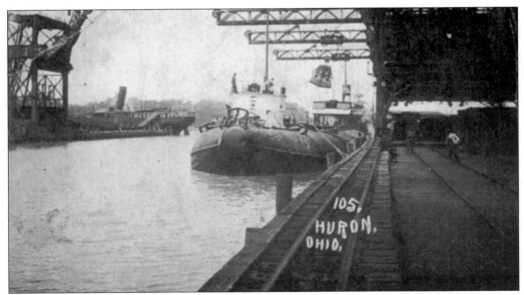

WHALEBACK AT HURON. Early in the 20th century, a whaleback freighter is unloading iron ore at Huron. Because it was served by the Wheeling and Lake Erie Railroad, Huron became a trans-shipment point for ore from the upper lakes and coal from West Virginia. The coal loading dock is just across the Huron River from the ore dock.

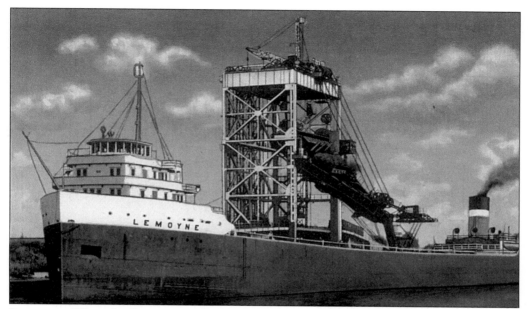

LEMOYNE. When the *Lemoyne* was built in 1926 for the Canadian Steamship Line, it was one of the largest bulk freighters on the lake. It was 630-feet long and 70-feet wide. Although frequently a grain carrier, the *Lemoyne* is loading coal at Huron. The fourth major improvement to the Welland Canal was officially opened when the *Lemoyne* passed through in August 1932.

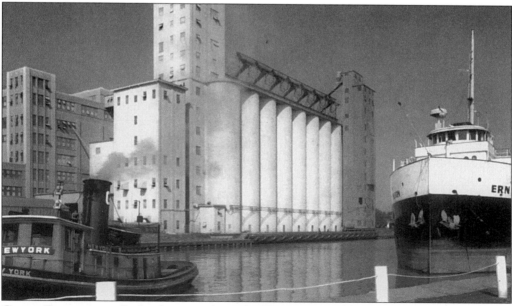

GRAIN ELEVATORS. Grain elevators along the Huron River dominated Huron's skyline. In the early 19th century, the small town of Milan just a few miles inland from Huron by canal and the Huron River had been a major grain port. Milan had been second in the world to Odessa, Russia in the quantity of grain shipped. But boats became so big that the canal could not accommodate them.

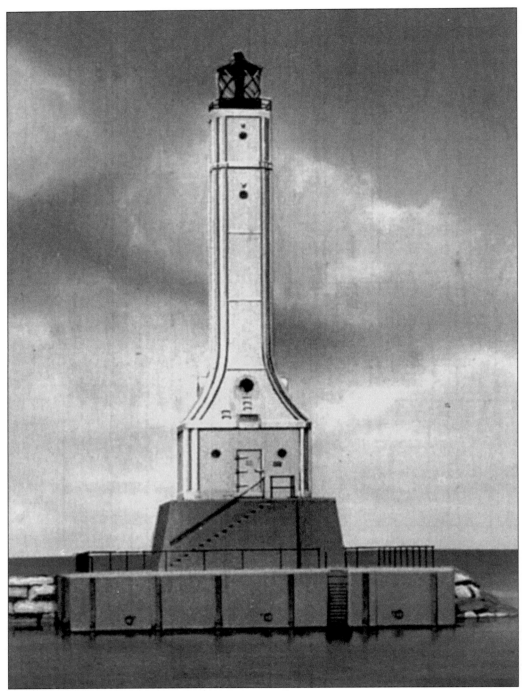

HURON LIGHTHOUSE. A wooden lighthouse built in 1847 was replaced by the one pictured in 1936. It is a steel tower with a concrete base. The art deco style was used in several other locations where lighthouses were built in the 1930s. See page 35 of this book for lighthouses at Conneaut that are similar. Huron is further south than any other port on the Great Lakes.

Six

SANDUSKY AND CEDAR POINT

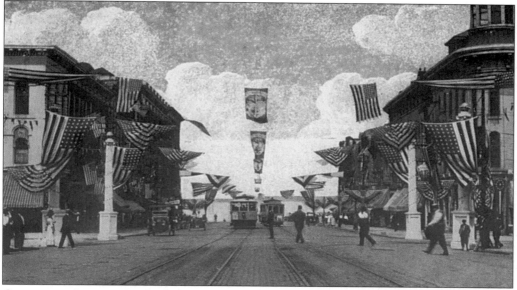

COLUMBUS AVENUE. Sandusky's main street, Columbus Avenue, leads to passenger docks on Sandusky Bay. Those docks served as a departure point for ferries to Cedar Point, ferries to Pelee Island and Leamington, Ontario, and boats on the island route to Kelleys Island, Marblehead, Lakeside, and the Bass Islands. Other docks served commercial shipping. The large passenger boats from Detroit, Toledo, and Cleveland had their own dock at Cedar Point.

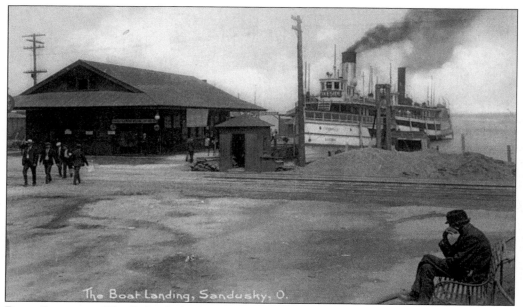

BOAT LANDING. The *Lakeside*, built in 1901, is shown in this 1905 picture of the Sandusky landing. Her bow was reinforced with iron plates so she could break through ice. The *Lakeside* ran the island route.

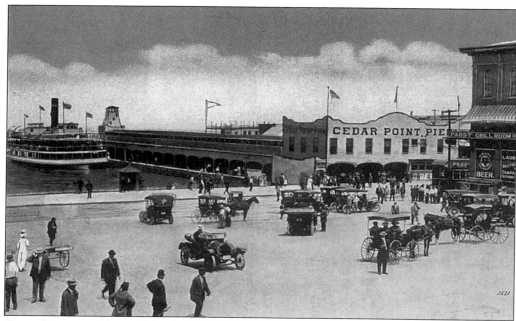

BOAT LANDING. Located in downtown Sandusky, boats departed for the short run to the resort at Cedar Point. Saloons at the landing were plentiful and at least one had a separate room for ladies. The *G.A. Boeckling* is at dock. Horse-drawn vehicles were beginning to be replaced by automobiles.

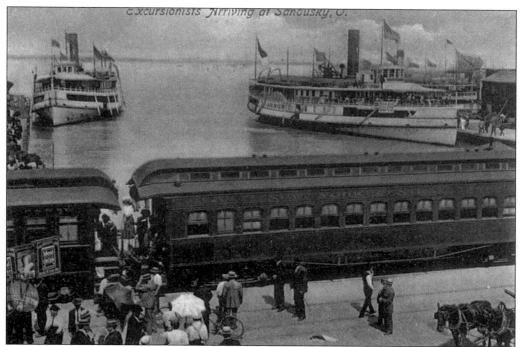

TRAINS AT BOAT LANDING. The popularity of resorts at Cedar Point, Lakeside, and Put-in-Bay owed some of their success to the fact that several railroad lines served Sandusky. On weekends it was not uncommon for 20,000 people to arrive by train in Sandusky and transfer to boats going to one of the resorts. The *Arrow* on the island route is at the right.

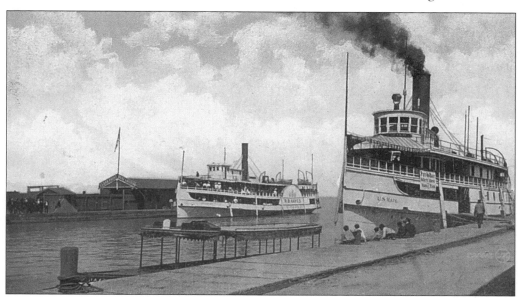

BOAT LANDING. On the left is the *R.B. Hayes*, named for an Ohio president. Built in Sandusky in 1876, the *Hayes* was ready for the two mile trip across the Bay to Cedar Point. The *Arrow*, on the right, is ready for a round trip on the island route.

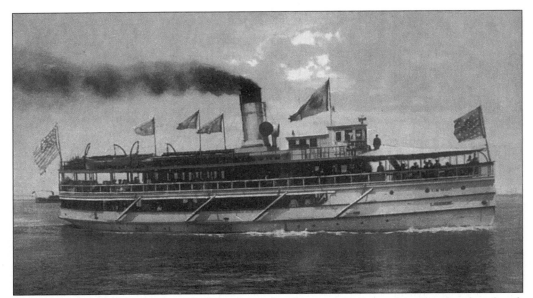

LAKESIDE. Built in 1901 at Toledo, the *Lakeside*'s steel hull was heavily plated to break through ice. Shown here in 1904 on the island route she was en route to Lakeside. In 1909 she made a daily trip from Cleveland to Port Stanley. In 1910 she made six round-trips a day from Buffalo to Fort Erie. In 1917 she was sold to the French government, renamed the *Olcott*, and taken to France. Later renamed the *Huron*, she was cut down to a tug.

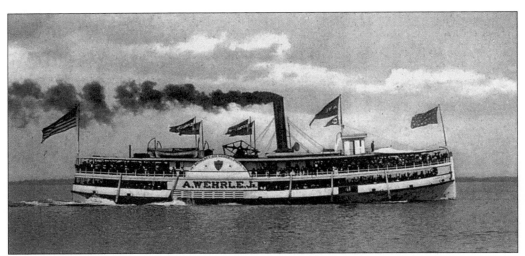

A. WEHRLE JR. Built in Sandusky in 1889, the *A. Wehrle Jr.* was named for her owner who used her in connection with his winery on Middle Bass Island. In 1891 she was sold to the Cedar Point Co. for use as a ferry. In 1915 she was sold again and by 1927, with engine and boilers removed, became the Cook County Democrat Party's Club at Chicago.

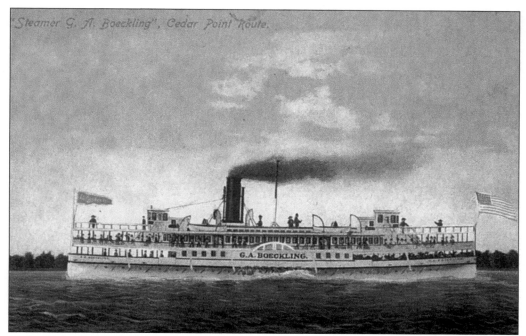

G.A. BOECKLING. After the Cedar Point Co. purchased the *G.A. Boeckling* in 1909, she became the major ferry from downtown Sandusky to Cedar Point. With a capacity of 1,800 passengers, she had two bows and two pilot houses, so it was not necessary to turn her around. Some years the *Boeckling* carried as many 700,000 passengers on the 20-minute run. She was in service until 1952.

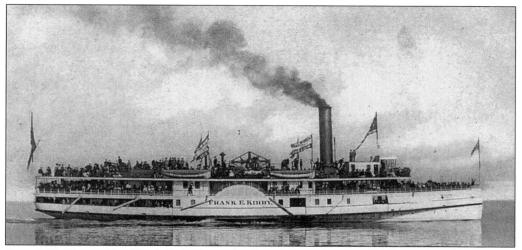

FRANK E. KIRBY. The *Frank E. Kirby* was built in 1890. Named for the marine architect who designed her, she was equipped with a rocker type engine. The rocker is the triangular shaped apparatus seen in the middle of the top deck. She ran many years from Detroit to Put-in-Bay and Sandusky, and later ran Detroit to Kingsville. Renamed the *Silver Spray*, she ran Erie to Port Dover. Finally, renamed the *Dover*, she was destroyed in a fire in 1932.

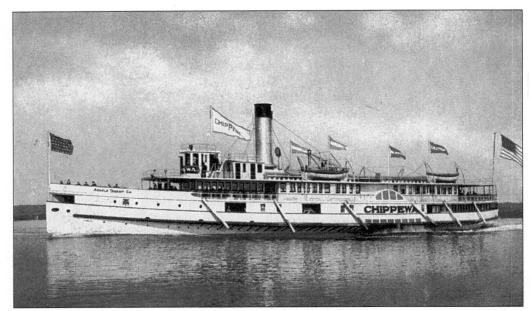

CHIPPEWA. Launched in 1883, the *Chippewa* was originally the U.S. Revenue Cutter *William Pitt Fessenden*. Built in Buffalo, she was first stationed on the lakes, but was ordered to Key West during the Spanish American War in 1898. Decommissioned and rebuilt as the *Chippewa*, she was on the Lakeside and island route from 1923 to 1938.

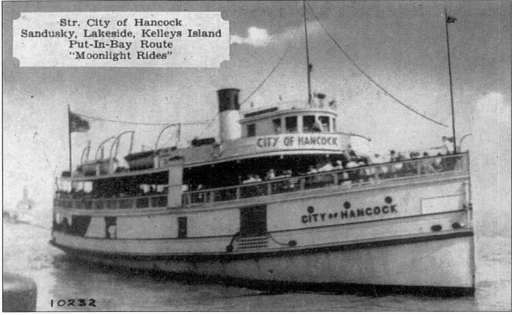

CITY OF HANCOCK. In 1939 the *City of Hancock* was the last boat to run the Sandusky to Lakeside and island route. Vacationers now went to Lakeside in the family automobile and to the islands by way of ferries that could also take their cars. The *Hancock* was built in 1901 and originally named the *Ossian Bedell*.

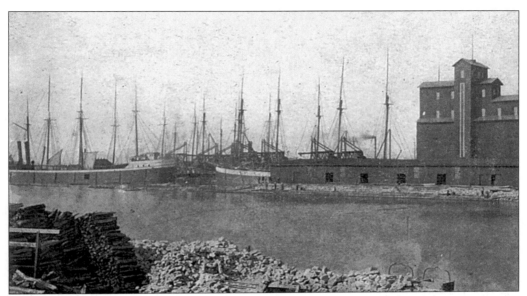

B & O DOCKS. Among Sandusky's major industries at the end of the 19th century were manufacturers of barrels, fish boxes, doors, and wagon wheels. Lumber is piled at the lower left. The B&O Docks handled such cargoes as stone and grain.

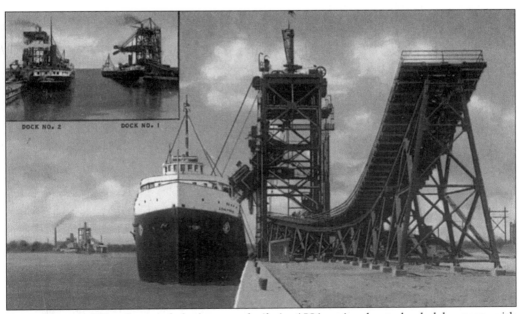

DOCK NO. 2 DOCK NO. 1

COAL DOCKS. The first coal docks were built in 1891, using boats loaded by men with wheelbarrows and then with hoists. Later, Docks No. 1 and No. 2 (shown in the inserts) were built with steam-powered car dumpers. The large dock in the picture was built in 1939. It had electric-powered equipment that could dump 60 90-ton cars of coal per hour. With some modification and enlarged space this dock is still in use in 2001. Coal shipped from here goes primarily to power plants in Detroit and Hamilton, Ontario and to steel mills at Hamilton.

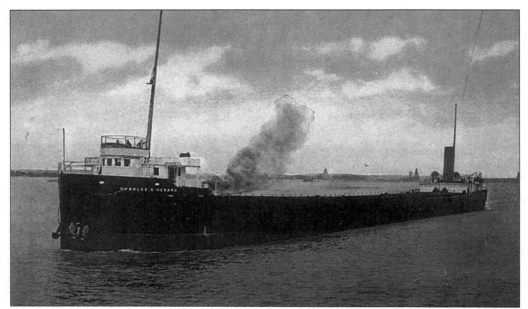

CHARLES S. HEBARD. The *Charles S. Hebard* is shown in Sandusky Bay. As boats became larger, attention had to be given to dredging deeper channels in the bay. Some commercial docks had to be shortened to provide more turning space for larger vessels.

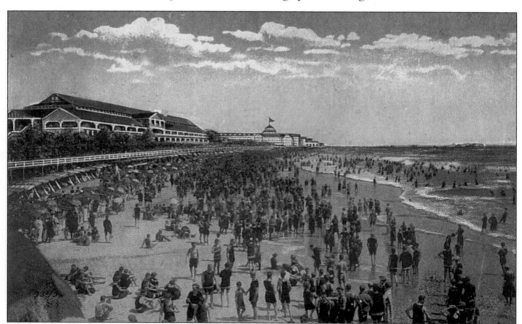

CEDAR POINT. Founded in the 1870s, the beach was an early attraction at Cedar Point. Hotel Breakers in the distance was built in 1905 with 600 rooms. The Coliseum in the foreground was built a few years later. It had an enormous dance hall on the second floor, which drew crowds through the big band era. In more recent years Cedar Point has become the roller coaster capital of the world.

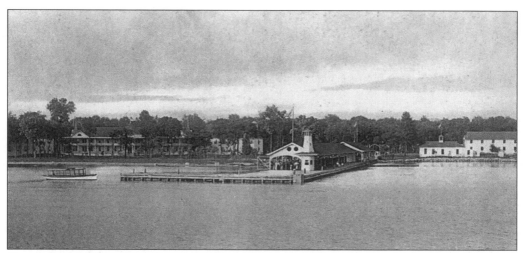

CEDAR POINT LANDING. Sandusky Bay has the Marblehead Peninsula on the west and the peninsula on which Cedar Point is located on the east. This 1905 postcard shows the landing for the large steamers that came to Cedar Point. On the left is the Bay Shore Hotel, built in 1901, which proved to be too small. When the passenger boat era ended, this landing was removed.

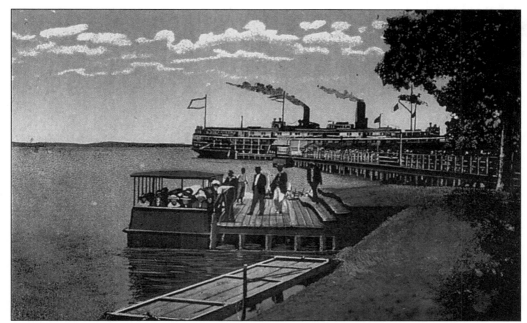

CEDAR POINT LANDING. Cedar Point was not accessible by road until 1914. The center of Cedar Point activities was at some distance from the boat landing. A series of lagoons had been built on the peninsula. Passengers could board the lagoon boat at lower left, built in 1911, and ride through the lagoons to the center of activities.

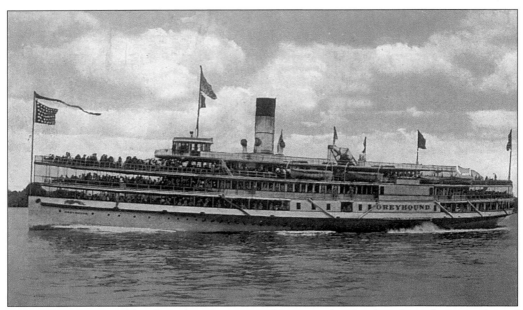

GREYHOUND. Owned by the White Star Line of Detroit, the *Greyhound* ran for a number of years between Detroit and Toledo. From 1925 until 1931, she provided service from Toledo to Cedar Point. The Great Depression of the 1930s plus the growing popularity of the family car would soon bring an end to passenger service to Cedar Point.

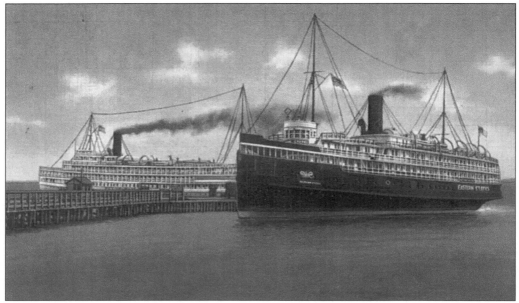

CLEVELAND AND DETROIT BOATS AT CEDAR POINT. The *Put-In-Bay*, on the left, ended regular service to Cedar Point from Detroit in 1948 and then made occasional excursions until 1951. The era of big passenger service to Cedar Point then ended. The Eastern States ran regularly from Cleveland from 1939 to 1942 and then in 1949 when its service ended.

Seven

MARBLEHEAD,
THE ISLANDS,
PORT CLINTON

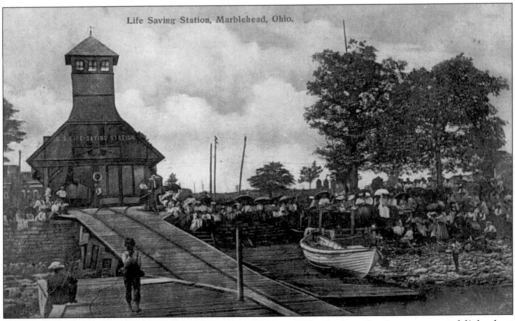

MARBLEHEAD LIFE SAVING STATION. In 1876 a Life Saving Station was established at Marblehead. Weekly practice sessions for launching rescue boats drew admiring crowds. Before the days of radio, a lookout was stationed in the tower to scan the horizon for boats that might need assistance.

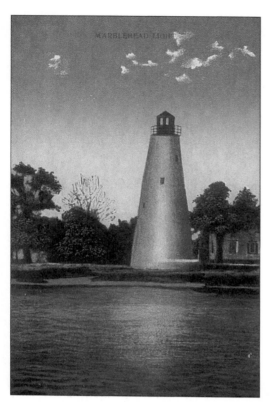

MARBLEHEAD LIGHTHOUSE. Built in 1821, the Marblehead Lighthouse is the oldest lighthouse on the Great Lakes in continuous operation. Built of local limestone, this picture shows how it looked until 1897 when 15 feet was added to the top. The adjacent keeper's house is now a museum and the property is in an Ohio State park.

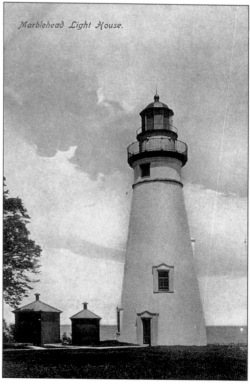

MARBLEHEAD LIGHTHOUSE. The Marblehead Lighthouse acquired a new look when a 15-foot addition was added to the top in 1897. The small buildings were used for storage of oil to light the lamps until the tower was electrified. A fourth order Fresnel Lens was installed in 1858 and remained until 1972.

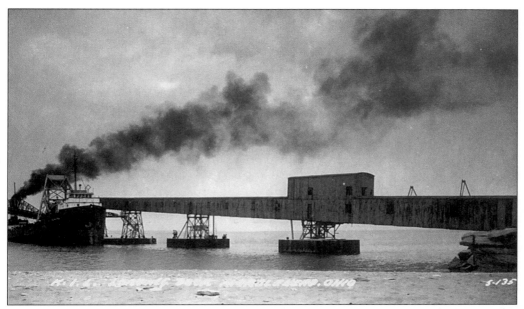

LOADING DOCK. For more than a century and a half, limestone from the local quarry has been Marblehead's chief export. The *Sumatra* is shown at the loading dock when the quarry was owned by the Kelly Island Lime and Transport Co. The *Sumatra* was built in 1897 as the *Empire City* and later was renamed the *Polonite*.

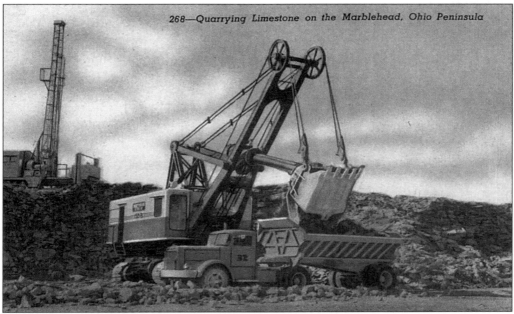

268—Quarrying Limestone on the Marblehead, Ohio Peninsula

MARBLEHEAD QUARRY. Limestone from the Marblehead quarry has been transported by boat to many lake ports. It has been used in many construction projects. Flux stone was essential in the steel making process. Marblehead stone has been a major ingredient in asphalt and concrete highways built in Ohio and West Virginia.

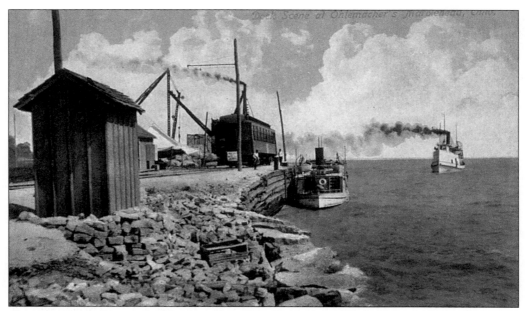

OHLEMACKER'S DOCK AT MARBLEHEAD. Until an automobile bridge across Sandusky Bay opened in 1929 it was a long land route from Marblehead to Sandusky. From 1908 to 1911 an interurban line from Toledo terminated at Ohlemacker's Dock in Marblehead. Passengers could take the *Hazel* or some other small boat for the short ride across the bay to Sandusky.

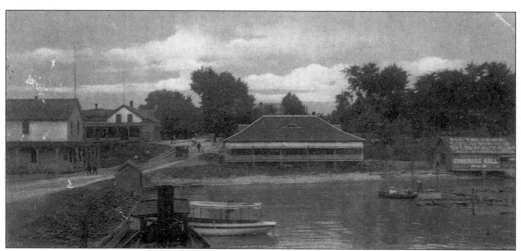

KELLEYS ISLAND. Located about four miles off shore from Marblehead, Kelleys Island is known for its vineyards and wine making. This is a 1905 view of its landing and of the Casino, a restaurant.

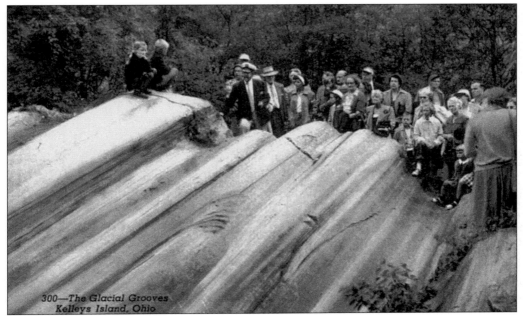

300—The Glacial Grooves
Kelleys Island, Ohio

GLACIAL GROOVES. Kelleys Island has the finest examples in the world of glacial grooves. In the 1950s tourists are seen listening to a lecture on the significance of glaciers in the formation of the lakes, islands, and mainland.

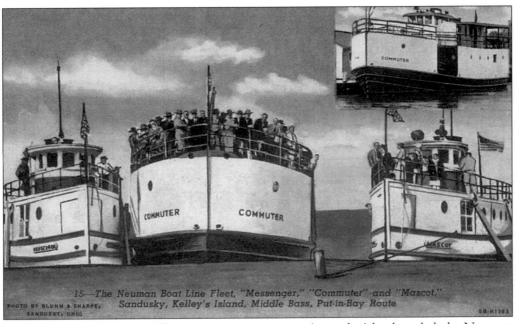

15—The Neuman Boat Line Fleet, "Messenger," "Commuter" and "Mascot,"
Sandusky, Kelley's Island, Middle Bass, Put-in-Bay Route
PHOTO BY BLUHM & SHARPE, SANDUSKY, OHIO

FERRIES TO THE ISLANDS. When steamer passenger service to the islands ended, the Neuman Boat Line founded early in the 20th century began to provide ferry service from both Sandusky and Marblehead to Kelleys Island and the Bass Islands. Among the line's ferries were the *Messenger*, built in 1921; the *Commuter*, built in 1945; and the *Mascot*, built in 1925.

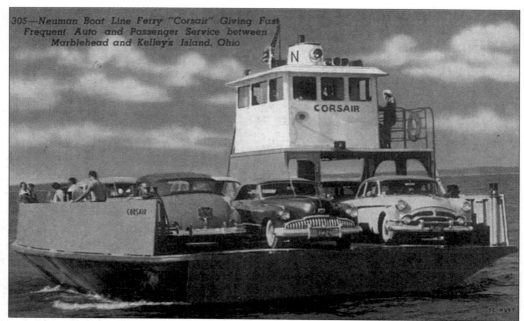

305—Neuman Boat Line Ferry "Corsair" Giving Fast Frequent Auto and Passenger Service between Marblehead and Kelley's Island, Ohio

CORSAIR. Since 1960, Marblehead has been the only departure point for Neuman Line ferries for Kelleys Island. The *Corsair*, a 60-foot diesel ferry, was built for this purpose in 1955.

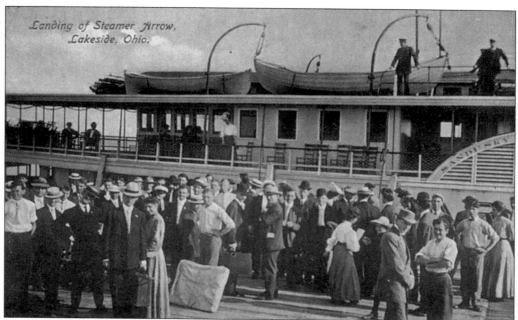

Landing of Steamer *Arrow*, Lakeside, Ohio.

ARROW AT LAKESIDE. Founded by Methodists in 1873 as a Christian family resort, Lakeside has long been known as "the Chautauqua on Lake Erie." In its early years most people came by boat. Passengers are shown waiting to board the *Arrow* which ran the island route from Sandusky from 1895 until burned at dock at Put-in-Bay in 1922.

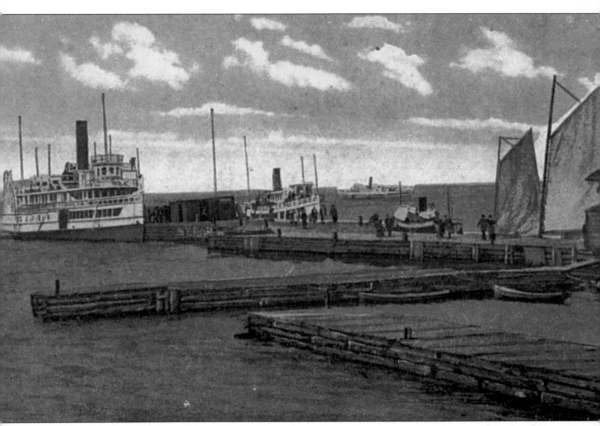

LAKESIDE LANDING. Four wooden boats are pictured at the Lakeside landing in 1898. On the left is the *Metropolis*, which ran to Toledo, Put-in-Bay, and Lakeside. On the other side of the dock is the *Osceola*, running Lakeside to Kelleys Island. Built in 1884 she ran Lakeside to Port Clinton and fishing charters. Later cut down to a fishing tug and renamed the *Winner*, she was abandoned in 1926 at Port Burwell. The *A. Wehrle Jr.* is seen coming in from Sandusky at upper right. The sailboats could operate inexpensively to other peninsula docks or to the islands. The rowboats in the foreground were for rent to vacationers. The wooden dock eventually became the foundation for Lakeside's 700-foot concrete dock. It is used today primarily for swimming and fishing and for the infrequent arrival of an excursion boat.

LAKESIDE'S BRADLEY TEMPLE. Captain Alva Bradley of Cleveland was owner of one of the largest fleet of boats on the lake. His family vacationed at Lakeside. After his death in 1887, his wife had Bradley Temple built at Lakeside in his memory. It is the smallest of four auditoriums in daily use during summers. Lakeside's largest auditorium seats 3,000 people.

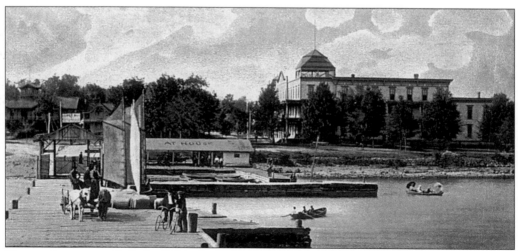

HOTEL LAKESIDE. Built in 1875 adjacent to the landing, Hotel Lakeside is still in use more than 125 years later. Its 100 rooms have been extensively renovated using some of the original furniture and other antiques.

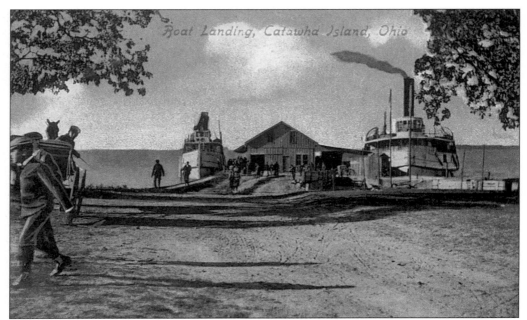

LANDING AT CATAWBA ISLAND. Actually a peninsula, not an island, Catawba Island was known during the first half of the 20th century for its vineyards and orchards. The *Falcon,* on the left, transported both people and fruit to Port Clinton and Sandusky. The *Frank E. Kirby,* on the right, sometimes took 5,000 bushels of peaches per trip to Detroit.

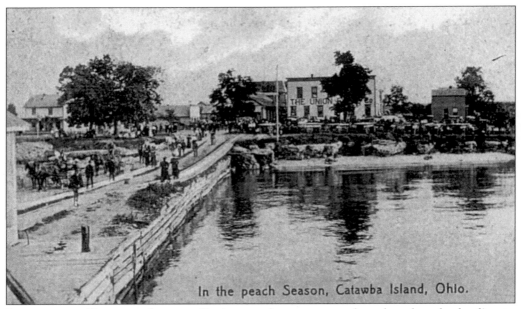

LANDING AT CATAWBA ISLAND. During peach season crowds gathered at the landing to watch the arrival of horse drawn wagons with bushels of peaches to be loaded on the boats. Today the landing at Catawba is known as the departure point for Miller Boat Line ferries to Put-in-Bay on South Bass Island.

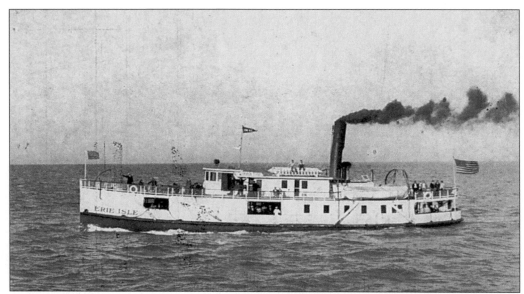

AUTO FERRY. Originally auto ferries to the islands were barges or scows towed by small boats. In the early 1930s, the *Erie Isle* was the first to carry both cars and people on the same boat. The *Erie Isle* ran from Catawba to Put-in-Bay. About 20 years later a second *Erie Isle* ran from Port Clinton to Put-in-Bay.

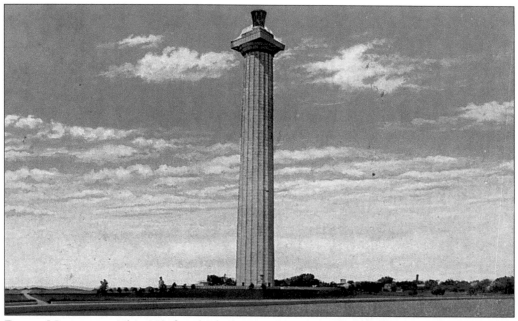

PERRY MEMORIAL. This 352-foot high Doric column is officially known as Perry's Victory and International Peace Memorial Monument. It commemorates the 1813 victory of United States Naval forces commanded by Oliver Hazard Perry over the British fleet commanded by Captain Robert H. Barclay during the War of 1812. It also recognizes the many years of peace along the United States–Canadian border.

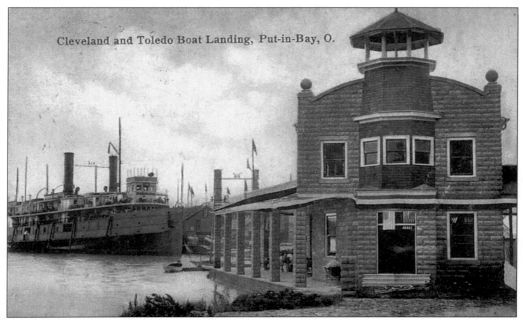

LANDING AT PUT-IN-BAY. By the 1860s, Put-in-Bay on South Bass Island had become a tourist destination. By the 1890s, large crowds came from Detroit, Toledo, and Cleveland to enjoy its beaches and wineries. This postcard mailed in 1907 pictures the landing for large steamers from major cities.

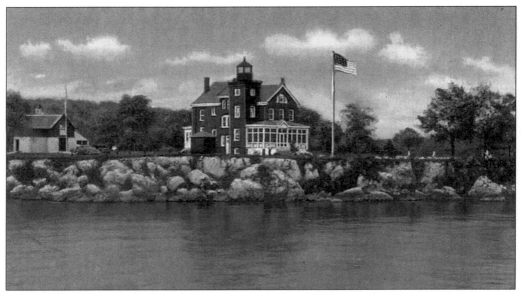

SOUTH BASS ISLAND LIGHTHOUSE. The South Bass Island Lighthouse began operation in 1897 and was replaced by a steel tower in 1962. Unlike many lighthouses of its era, the 60-foot tower was attached to the keeper's house. Today the property is owned by Ohio State University and is used in connection with Ohio State's extensive Lake Erie research and academic programs on South Bass and Gibralter Islands.

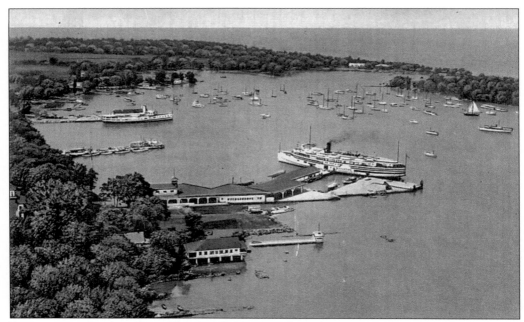

LANDING AT PUT-IN-BAY. This is a 1930s view from the Perry Monument of the bay and several landings. The *Chippewa* on the island route from Sandusky is on the left. The *Goodtime* from Cleveland is at the end of the landing in the center. Many pleasure boats dot the bay.

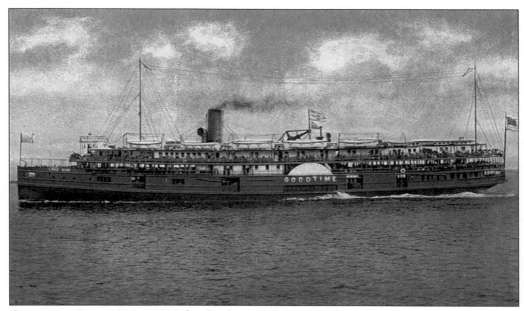

GOODTIME. From 1925 to 1938 the *Goodtime* made round-trips to Put-in-Bay from Cleveland. The *Goodtime* had been launched in 1890 as the *Detroit II* for the D&C Line. She was renovated in 1924 as the *Goodtime* for the C&B Line. She was scrapped at Erie about 1940.

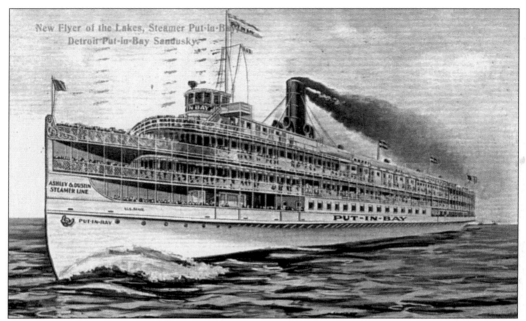

PUT-IN-BAY. Launched at Wyandotte, Michigan in 1911, the *Put-In-Bay* was 240-feet long and 46 feet wide. The hull and main deck were iron with a wooden superstructure. With a passenger capacity of 2,800, the boat featured a 200-foot long ballroom. From 1911 to 1948 she ran Detroit to Put-in-Bay and most years on to Cedar Point. Occasional excursions were made to other ports.

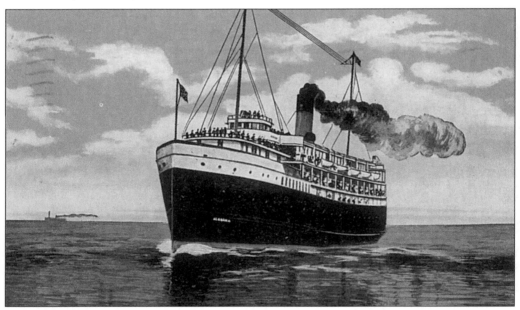

ALABAMA. One of the last boats to have a regular service from Cleveland to Put-in-Bay was the *Alabama*. She ran in 1946 with a stop at Cedar Point. Boat service from Detroit to Put-in-Bay ceased in 1951 and from Cleveland in 1949. Since then it has been the ferry boats that have brought passengers to the islands.

REGATTA AT PUT-IN-BAY. The Inter-Lake Yachting Association was organized at Put-in-Bay in 1885. Its annual regattas have been held there almost every year since. Pictured are a few of the regatta sailing craft in the 1950s.

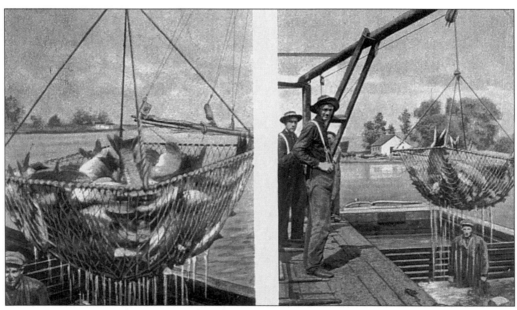

PORT CLINTON. Both commercial and recreational fishing have been major factors in Port Clinton's economy. The catch was good when this card was mailed in 1908. Some commercial fishing is still done, but Port Clinton is better known in the 21st century as "the Walleye Capital of the World" and as a center for recreational fishing.

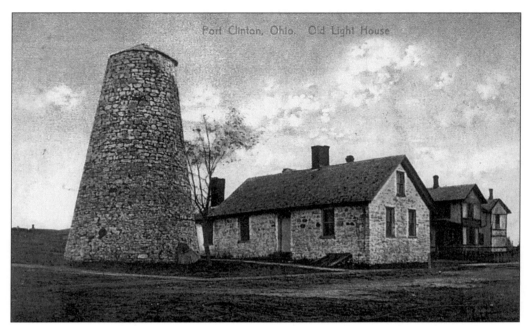

PORT CLINTON LIGHTHOUSE. The first Port Clinton Lighthouse with adjacent keeper's house was built in 1833. Because there was so little maritime activity, it was not lighted after 1870, and in 1899 was torn down. The Portage River was very narrow and Port Clinton did not develop industries that relied upon shipping.

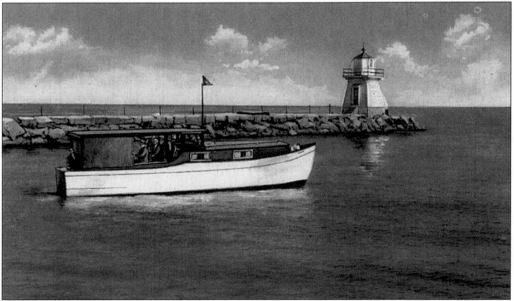

SECOND PORT CLINTON LIGHTHOUSE. In 1896 a second lighthouse was built on the breakwater at the mouth of the Portage River. When replaced by a light on a steel frame, this lighthouse was removed to a private marina. The cruiser in the picture is typical of the style built by the Matthews Boat Co., which operated in Port Clinton from 1906 to 1974.

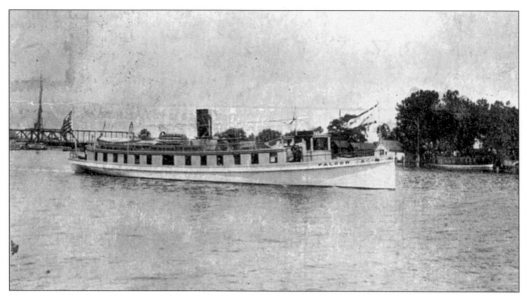

FALCON. During the late 1800s and early 1900s, the *Falcon* provided passenger service to a number of destinations in the Port Clinton/Sandusky area. Shown here at Port Clinton, she was a familiar sight at Catawba and other docks on the Marblehead Peninsula. At various times, she ran out of Sandusky to a short lived resort on Johnson's Island, to Cedar Point, and to the end of the interurban line from Toledo at Ohlemacker's Dock or Bay Point on the peninsula.

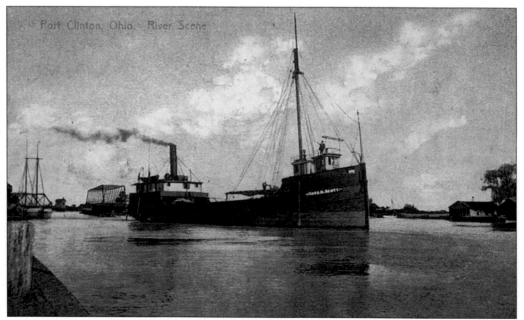

THOMAS R. SCOTT. One of the few products shipped from Port Clinton was lumber. That may have been the cargo of the *Thomas R. Scott*. She was a wooden propeller built in 1887 with U.S. ownership that was transferred to Canadian ownership in 1907. She was 129-feet long, 28-feet wide, with a draft of just over 7 feet. She foundered in Georgian Bay in 1914.

Eight
TOLEDO

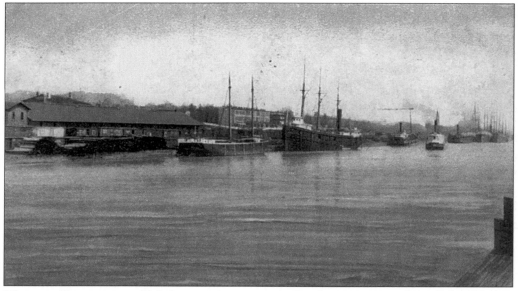

MAUMEE RIVERFRONT. Toledo owes its economic development not only to Lake Erie but also to the wide Maumee River that provided ample dock space. In the mid-19th century the river was used as part of the route for a canal to the Ohio River. The Pennsylvania Railroad docks are on the left on this postcard mailed in 1906.

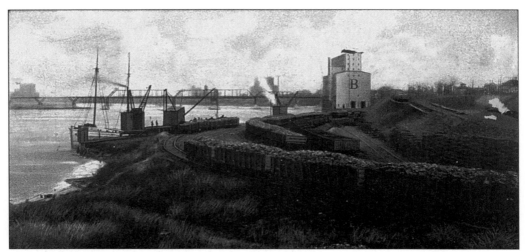

TOLEDO HARBOR. Two products shipped from Toledo are shown in this picture: grain and coal. Steel mills and electric power plants required large quantities of coal. Before World War II, many homes were heated with coal-fired furnaces. Consequently, small towns along the lake required coal for retail sale to homeowners.

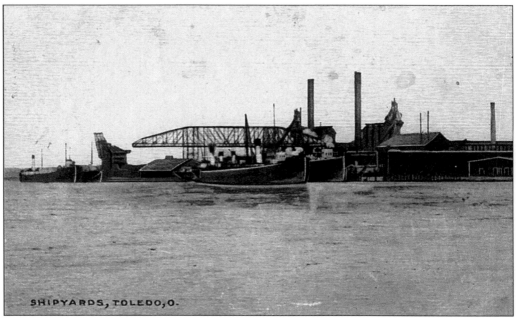

SHIPYARDS, TOLEDO, O.

TOLEDO BOATYARDS. Boat building has a long history in Toledo. A major company started in 1890s was the Craig Ship Building Co. It built elegant yachts, railroad car ferries used at Ashtabula, freighters of wood or a combination of wood and iron, and passenger steamers such as the *City of Toledo*.

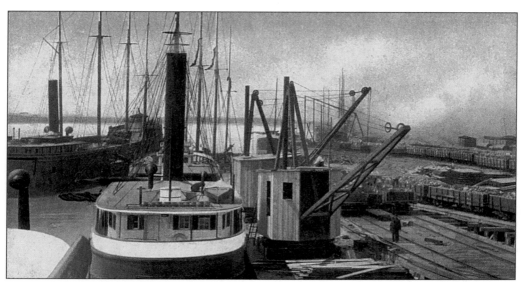

TOLEDO COAL DOCKS. This 1908 postcard of the Toledo and Hawking Valley coal docks shows equipment known as rotary derricks or whirlies. Buckets attached to the derrick could lift coal from a railroad car and whirl around to dump it into a freighter.

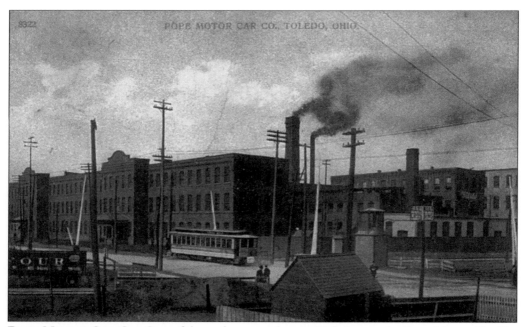

POPE MOTOR CAR CO. One of the early automakers in Toledo was the Pope Motor Car Co. It was purchased by the Willys Overland Co. in 1911, and by 1928, employed 23,000 people. Toledo's Jeep Plant of 2001 is a direct descendant. Early automakers often shipped new cars by boat.

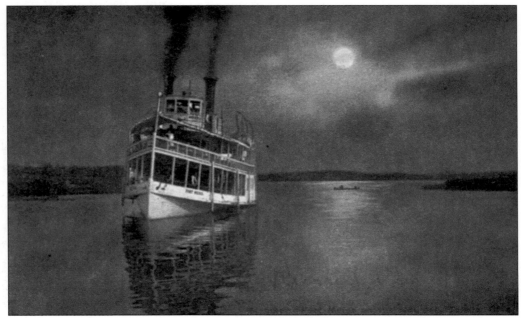

FORT MEIGS. The Maumee River was navigable beyond the dock area and beyond the town of Perrysburg where the site of Fort Meigs is located. A pleasant entertainment was a moonlight cruise on the small steamer called the *Fort Meigs*. Fort Meigs on the Maumee River was the site of a War of 1812 battle between United States forces and the British and their Indian allies.

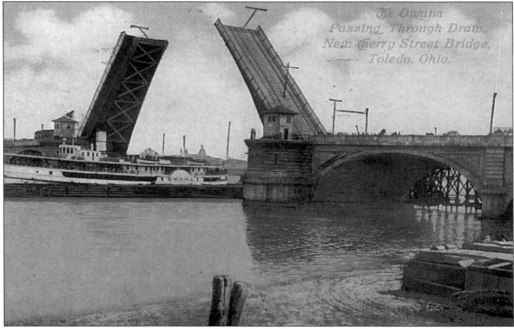

OWANA. Owned by the White Star Line, the *Owana* ran regularly from Toledo to Detroit. She is seen here passing under the Cherry Street Bridge on a card postmarked 1914.

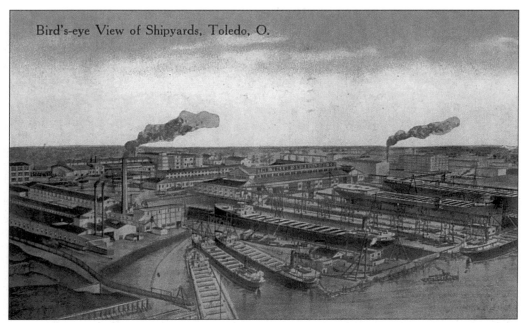

TOLEDO SHIP BUILDING CO. The boat yards of the Toledo Ship Building Co. in this 1916 picture indicate its large capacity for construction and repairs. It made important contributions to naval preparedness in both World Wars.

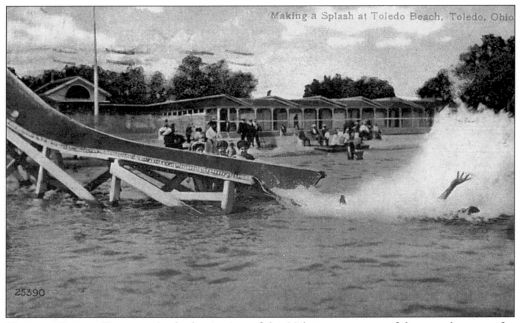

TOLEDO BEACH RESORT. At the beginning of the 20th century, one of the popular spots for outdoor recreation was the resort called Toledo Beach. It was located on the lake just north of Toledo near the Michigan state line. The water toboggan was one of the big attractions.

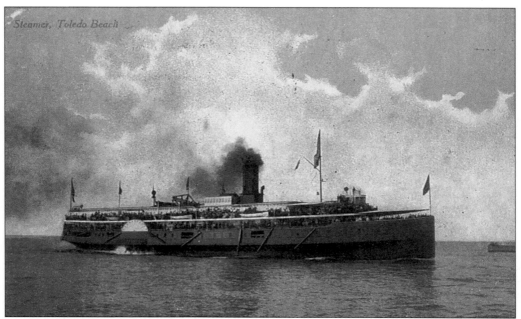

Steamer, Toledo Beach

STEAMER *TOLEDO BEACH*. Did the resort or the side-wheeler acquire the name *Toledo Beach* first? Like so many boats of its era, the *Toledo Beach* was built to carry both passengers and freight. It had a rocker type engine evidenced by the triangular shaped rocker behind the smoke stack.

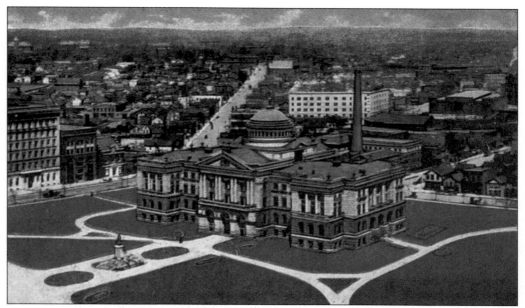

COURT HOUSE. The Lucas County Court House in Toledo was an imposing structure at the turn of the century. The early Toledo skyline did not match its grandeur. Most of the area in the picture has been cleared for construction of larger buildings.

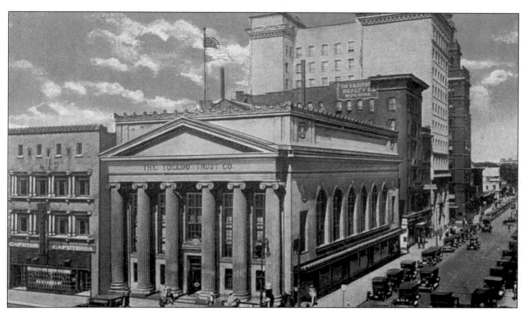

TOLEDO TRUST CO. Another building of classical style was the Toledo Trust Co. It did not dwarf the Carpenter Cafeteria next door. Automobiles were just beginning to create a parking problem.

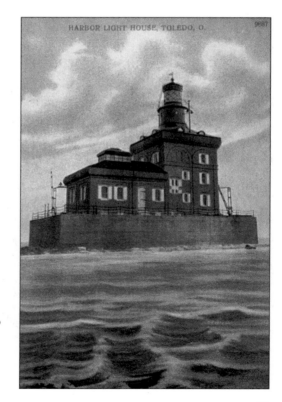

TOLEDO HARBOR LIGHTHOUSE. The architecture of the lighthouse in the Toledo Harbor matched the classic grandeur of its public buildings. Established in 1904, the lighthouse was automated in 1965. It is accessible only by boat.

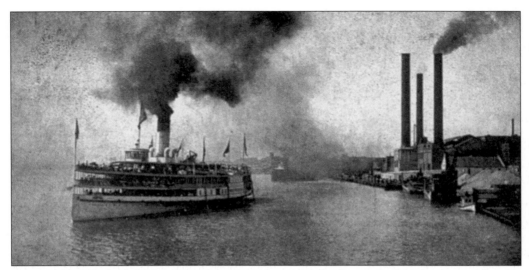

GREYHOUND. Built in 1902 at Wyandotte, Michigan, the *Greyhound* was 144-feet long with a 60-foot beam. For some years she ran Detroit to Toledo and later Toledo to Put-in-Bay and Cedar Point. This postcard, mailed in 1909, gives a glimpse of the Maumee River waterfront of that day.

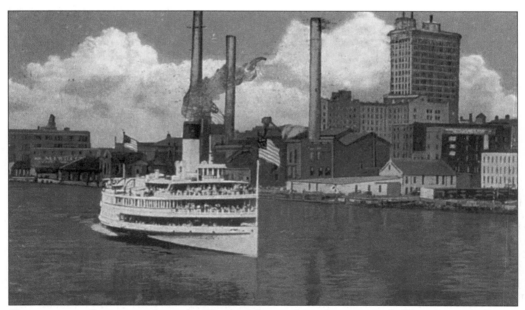

GREYHOUND. Some years later the *Greyhound* graced another postcard. The picture indicates improvements made to the Toledo waterfront. The White Star Line's *Greyhound* had a reputation for speed.

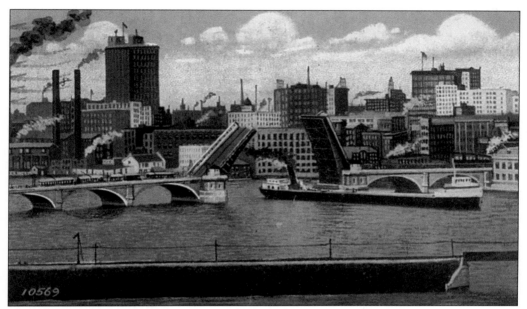

TOLEDO HARBOR. This postcard showing a freighter passing through the Cherry Street Bridge was mailed in 1921. The skyline was beginning to take on a prosperous, modern look. The constant need to open the bridge resulted in planning for future bridges to be high enough for boats to sail under them.

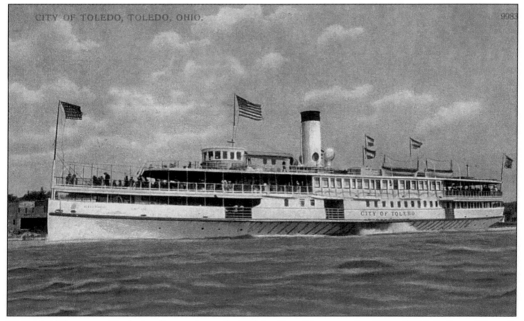

CITY OF TOLEDO. Early in the century the White Star Line ran the *City of Toledo* from Detroit to Port Huron. Later under Ashley and Dustin ownership, she ran other routes including Detroit to Cedar Point in 1926.

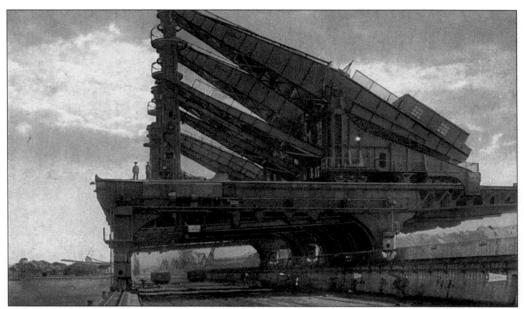

HULETT UNLOADERS. Toledo had Hulett electric unloaders as did other high volume ports. With several parallel railroad tracks, boats could be unloaded with dispatch. Freighters with self-unloading equipment were soon to make the Huletts obsolete. In 2001 all the Huletts on Lake Erie have been removed much to the despair of preservationists.

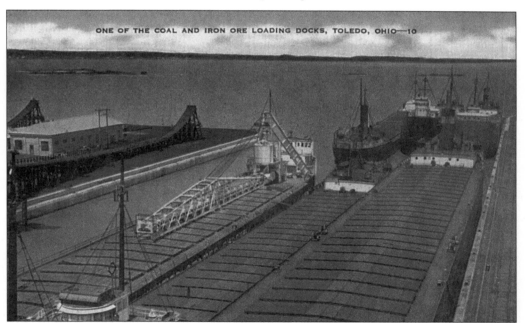

ONE OF THE COAL AND IRON ORE LOADING DOCKS, TOLEDO, OHIO—10

TOLEDO COAL AND IRON ORE DOCKS. Toledo was considered the largest bituminous coal port in the world. The freighter on the left is the only one with self unloading equipment. If the other freighters were to stay competitive, they were likely to have unloading equipment added too.

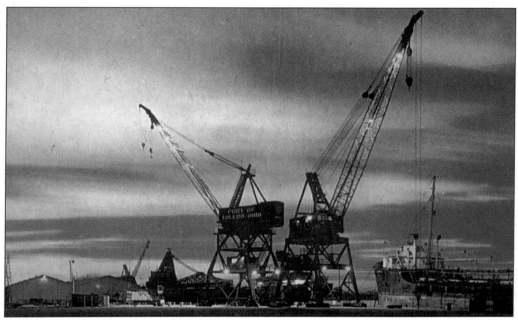

GANTRY CRANES. In order to load package freight into the hold or on the deck of a freighter, the Toledo–Lucas County Port Authority installed heavy-duty gantry cranes. They became known as "Big Lucas" and "Little Lucas" and could load separately or in tandem.

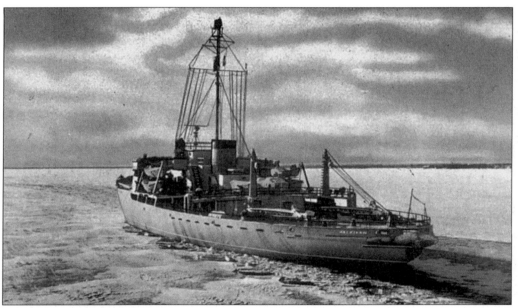

ICE BREAKER *MACKINAW*. The *Mackinaw* was built at Toledo for the U.S. Coast Guard during World War II in order to keep shipping lanes open for transport of vital war materials. It is sometimes called "the ship the girls built" because so many women were working in the shipyards. She can break through ice that is 15 to 18-inches thick. Still at work during the winter of 2000/2001, there are plans for her retirement.

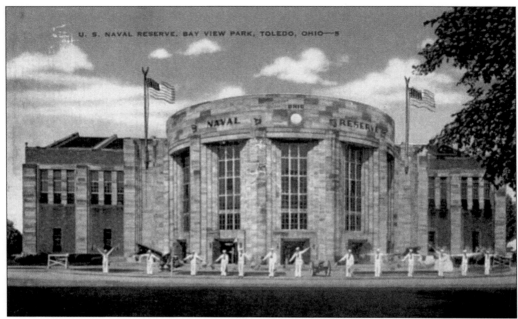

U.S. NAVAL RESERVE. Before radio communication became commonplace, naval reservists were trained to communicate with wig-wag flags. The dots and dashes of Morse Code were translated into the positions of the small flags held by sailors.

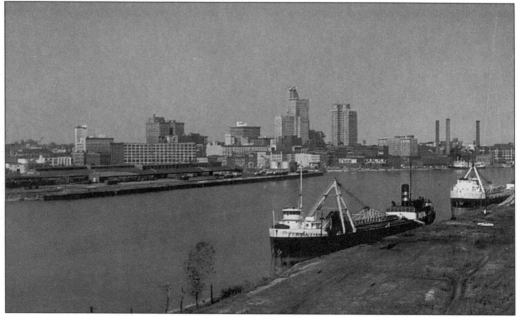

TOLEDO HARBOR. When the St. Lawrence Seaway was completed in 1959, ships from around the world could call at Toledo and other Lake Erie ports. The slogan "Key to the Sea" was sometimes used to describe the port of Toledo.

Nine
DETROIT

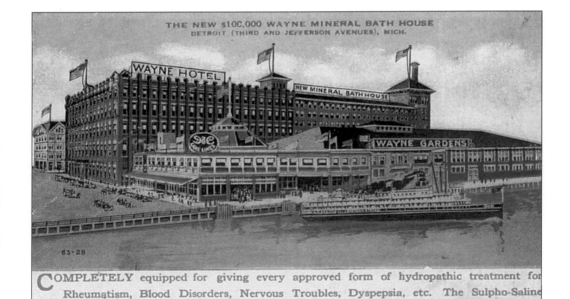

THE NEW $100,000 WAYNE MINERAL BATH HOUSE
DETROIT (THIRD AND JEFFERSON AVENUES), MICH.

WAYNE HOTEL

NEW MINERAL BATH HOUSE

WAYNE GARDENS

63-28

COMPLETELY equipped for giving every approved form of hydropathic treatment for Rheumatism, Blood Disorders, Nervous Troubles, Dyspepsia, etc. The Sulpho-Saline water is not excelled in therapeutic value by any spring in America or Europe.

WAYNE HOTEL. In the Victorian era, it was popular to go to resort hotels to "take the waters" as a cure for your ailments. The Wayne Hotel was adjacent to the New Mineral Bath House where the baths would cure just about anything.

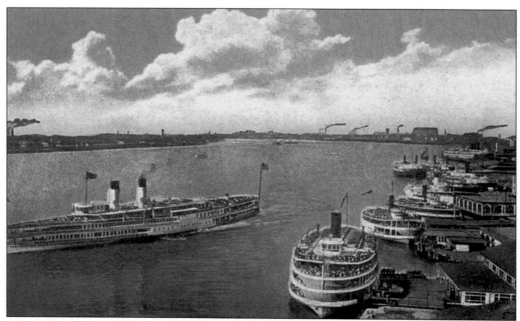

WHITE STAR LINE DOCKS. With boats all painted white, the White Star Line had its own docks on the Detroit River. The *Tashmoo*, the line's flagship, is shown pulling away from the docks. It was the *Tashmoo* that was defeated by the *City of Erie* in the 1901 race from Cleveland to Erie by just 45 seconds.

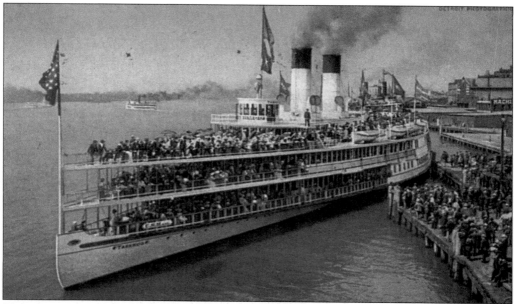

TASHMOO. Another view shows the popular *Tashmoo* with a capacity crowd in this 1901 picture. The *Tashmoo* met her fate in 1936 during an evening cruise on the Detroit River. She hit something, probably a rock, which tore a hole in her hull. She was able to reach the Amherstburg dock and discharge all passengers before the boat sank and had to be dismantled.

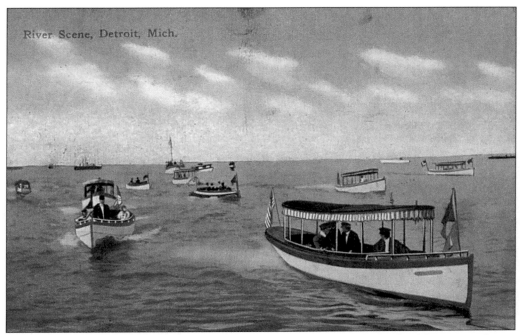

RECREATIONAL BOATING. Mailed in 1912, the blurb printed on the back of the postcard says, "The Detroit River has always been noted for the facilities afforded to all who are fond of aquatic sport. Gasoline launches and motor boats predominate and almost any summer afternoon and evening the river will be found thickly covered with small craft."

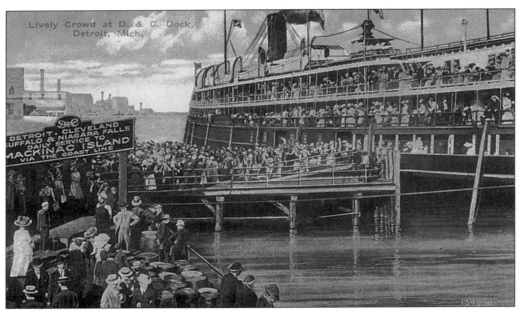

D& CDOCK. Hundreds of people gathered to board boats at the Detroit and Cleveland Line Dock for overnight trips to Buffalo or to Cleveland or day trips to Mackinac Island. The D&C Line was incorporated in 1868.

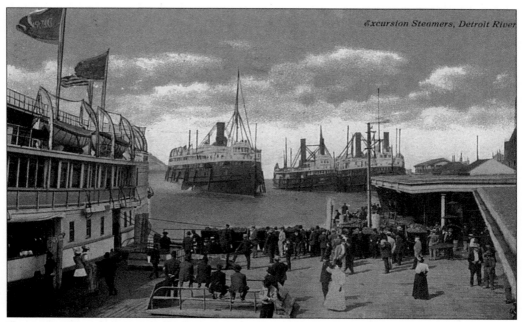

DETROIT HARBOR. Four D&C steamers are waiting to dock. The D&C boats were recognizable from a distance because they all had black hulls, cream-colored superstructure, and black smokestacks.

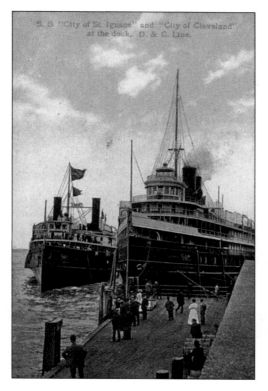

D&C DOCK. About 1910 the *City of St. Ignace* and the *City of Cleveland* were at the D&C Dock. These were two of the line's smaller boats soon to be replaced by larger ones.

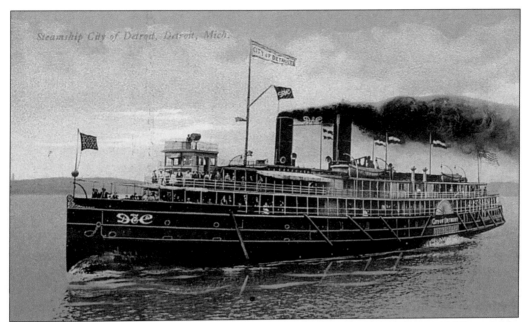

CITY OF DETROIT. Over the decades, a number of boats have included the word "Detroit" in their names. The *City of Detroit* pictured here was launched in 1878 for the D&C Line.

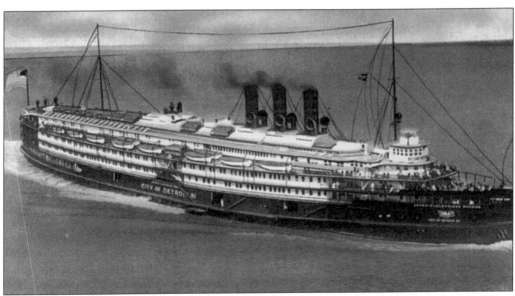

CITY OF DETROIT III. The D&C Line's *City of Detroit III* was 470-feet long and had a beam of 93 feet. She had a capacity of 1,440 passengers and a crew of 230.

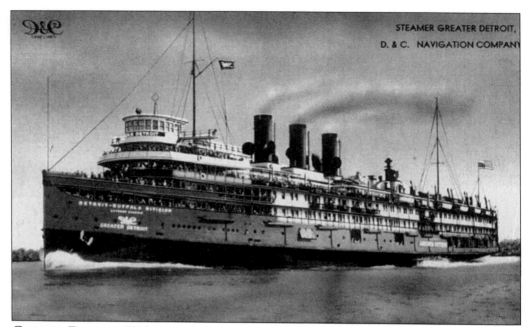

GREATER DETRIOT. With a passenger capacity of 2,127 and 625 staterooms, the *Greater Detroit* was launched for the D&C Line in 1924. She was 536-feet long and 96-feet wide. She was the beginning of the end of the great passenger boats. The Great Depression, World War II, more stringent government regulations, and better highways for the family car all contributed to a decline in passenger service.

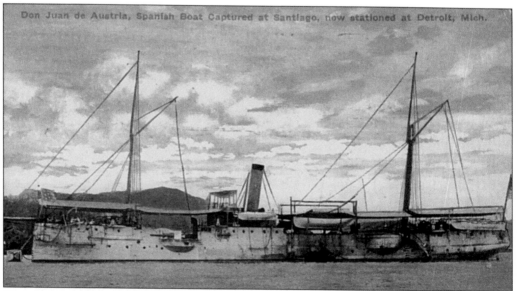

Don Juan de Austria, Spanish Boat Captured at Santiago, now stationed at Detroit, Mich.

DON JUAN DE AUSTRIA. An interesting Spanish warship, the *Don Juan de Austria*, was on the Detroit waterfront. It had been captured near Cuba during the Spanish American War in 1898. It was awarded as a war trophy to the Michigan Naval Reserves for training purposes and was stationed at Detroit.

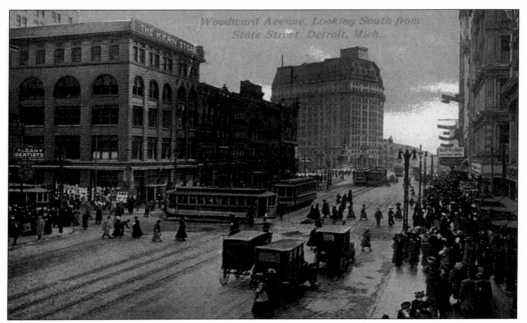

WOODWARD AVENUE. At the turn of the century, large crowds patronized businesses on Woodward Avenue. Many came by trolley. No one would have predicted the effect that automobiles would have on Detroit's economy.

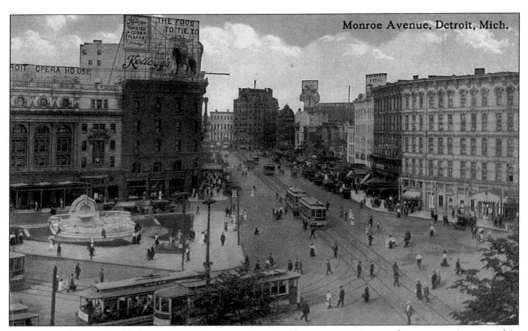

MONROE AVENUE. Campus Martius, meaning "military camp," was the name given to this area during frontier days. Monroe Avenue became the theater district. The Opera House on the left has been restored.

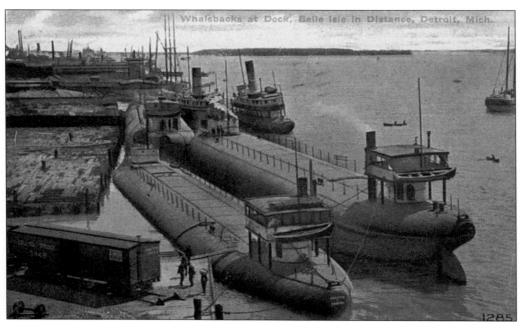

WHALEBACKS. A total of 46 whalebacks were built between 1888 and 1898 primarily to transport grain or coal. Designed by Alexander McDougall, they were sometimes called pigs because the shape of their bows resembled a pig's snout, and because of their shape, they were sometimes called floating cigars.

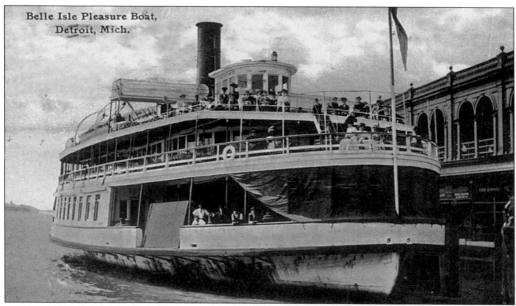

PROMISE TO BELLE ISLE. Steamers left the foot of Woodward Avenue every 15 minutes for Belle Isle, the popular island park for recreation. The *Promise* was one of those boats, around 1910. Activities at Belle Isle included an aquarium, horticultural gardens, picnic grounds, canals for boating, and boat clubs.

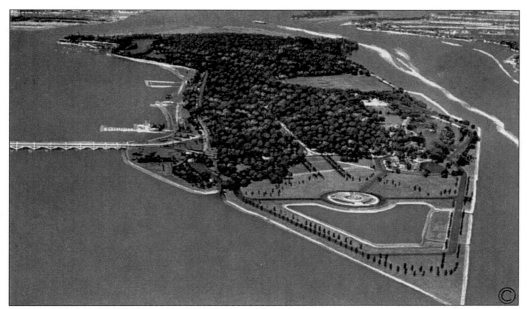

BELLE ISLE. Mailed in 1938, this postcard gives an aerial view of Belle Isle. In the 1930s it was accessible by a bridge and boasted 20 miles of roads. In 2001 it is still in use as a beautiful park.

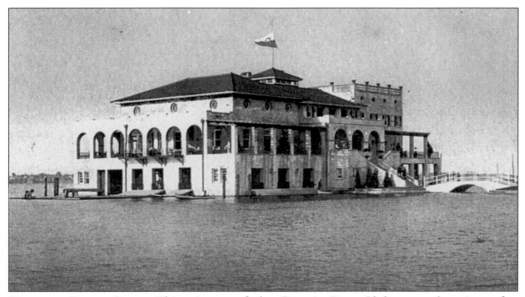

DETROIT BOAT CLUB. This picture of the Detroit Boat Club was taken just after construction was completed in 1902. It replaced an earlier building. It was an exclusive social club where rowing was combined with fancy parties and elegant balls.

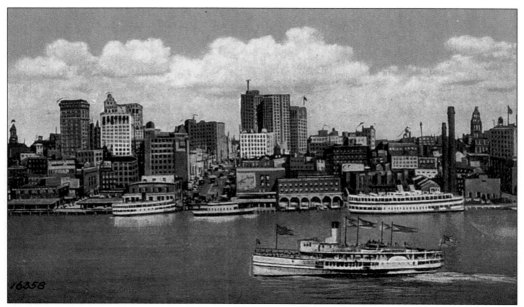

DETROIT WATERFRONT. The postcards on these pages taken at different dates show a changing skyline. Detroit made rapid economic growth in the first decades of the 20th century as it became the automobile capital of the world.

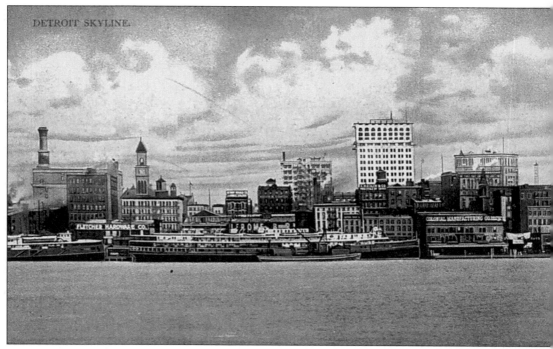

DETROIT WATERFRONT. This page and the adjacent page have a panoramic view of Detroit's waterfront from a double postcard. The scene emphasizes how Detroit's economy depended upon its strategic location between Lake Erie and the upper lakes.

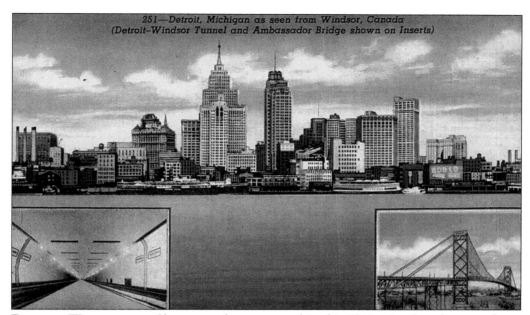

251—Detroit, Michigan as seen from Windsor, Canada
(Detroit–Windsor Tunnel and Ambassador Bridge shown on Inserts)

DETROIT WATERFRONT. Skyscrapers have appeared in this 1940s view but there are fewer boats. Inserts are of the auto tunnel to Windsor as well as of the Ambassador Bridge. A large sign at lower right advertises the boat ride to Bob Lo Island.

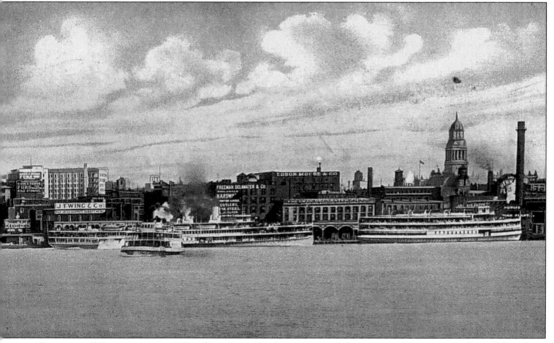

DETROIT WATERFRONT. The ferry boat in the center of the postcard is a reminder of the close relationship Detroit and Windsor have enjoyed. In 2001, Detroit is celebrating its tricentennial, as well as its history of having been under the French, British, and United States flags.

WILLIAM LIVINGSTONE. The freighter *William Livingstone* was named in honor of a Detroit resident. Ship owner and president of the Lake Carriers Association, Livingstone (1844–1925) advocated improvements to channels and locks to accommodate larger boats. There is a channel named for Livingstone toward the lower end of the Detroit River.

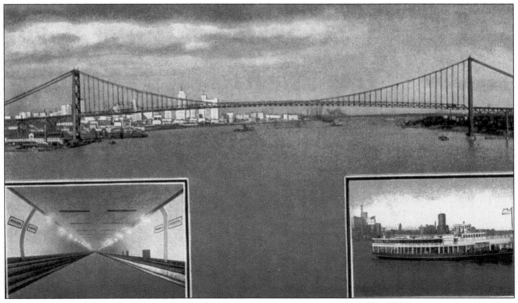

AMBASSADOR BRIDGE. When the Ambassador Bridge was completed in 1929 connecting Detroit and Windsor, Ontario, use of the ferry pictured in the insert began to decline. Ferries stopped running in 1938. The tunnel pictured in the other insert also connected the two countries.

Ten

ONTARIO

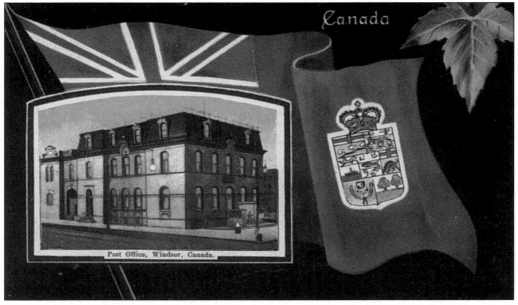

WINDSOR POST OFFICE. Windsor, Ontario is just across the Detroit River from Detroit. A picture of the old post office is superimposed on Canada's former flag. That flag had the British Union Jack in the upper left hand corner. Canada's flag today features the maple leaf.

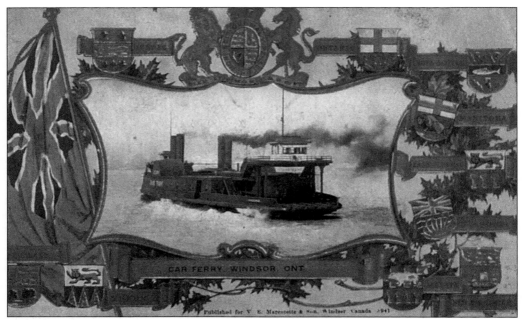

CAR FERRY. The term "car ferry" developed to describe ferries for railroad cars before automobiles were in general use. This postcard was mailed in 1909. The border includes the flag of each Canadian province.

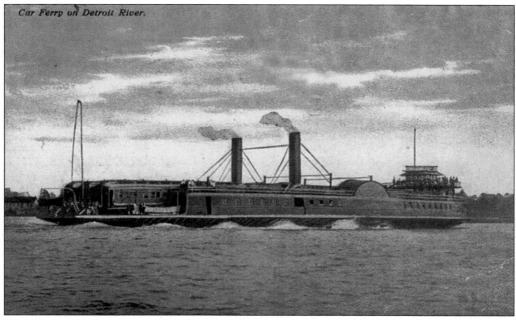

CAR FERRY. Railroad cars were lined up three abreast and at least three deep on this ferry between Detroit and Windsor. The postcard was mailed in 1911.

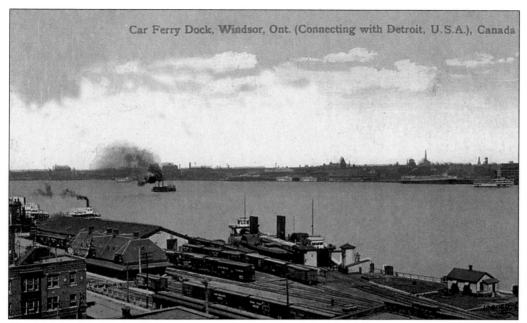

Car Ferry Dock, Windsor, Ont. (Connecting with Detroit, U.S.A.), Canada

CAR FERRY DOCK. With Detroit's modest pre–World War I skyline in the background, a railroad car ferry is shown at dock in Windsor. The building with the gabled roof near lower left was Windsor's passenger train station. The area near the river is now a park.

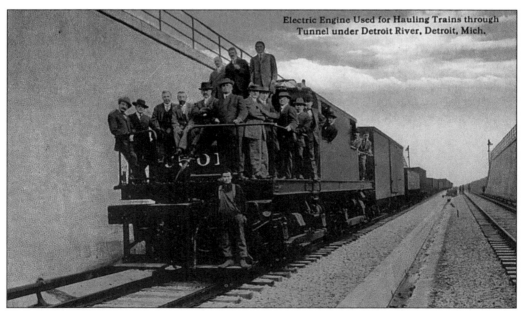

Electric Engine Used for Hauling Trains through Tunnel under Detroit River, Detroit, Mich.

RAILROAD TUNNEL. The need for car ferries was eliminated when a railroad tunnel was built under the Detroit River. The tunnel was nearly a mile and a half long. A third rail system furnished the power for electric engines that brought trains through the tunnel.

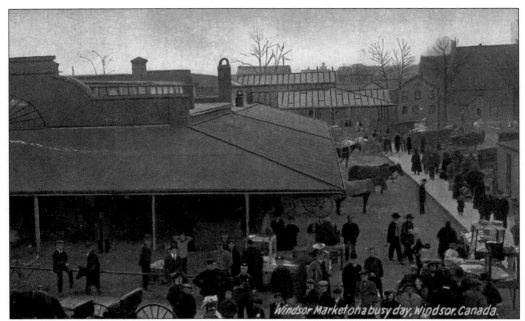

WINDSOR MARKET. The Windsor Market was a busy place in the days before supermarkets. It was not only a place to shop but also a place for socializing.

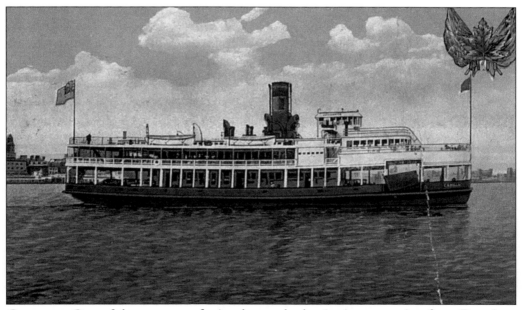

CADILLAC. One of the passenger ferries that made the 6-minute crossing from Detroit to Windsor was the *Cadillac*. With a capacity of 2,500 passengers and 75 automobiles, the *Cadillac* ferried thousands of people everyday.

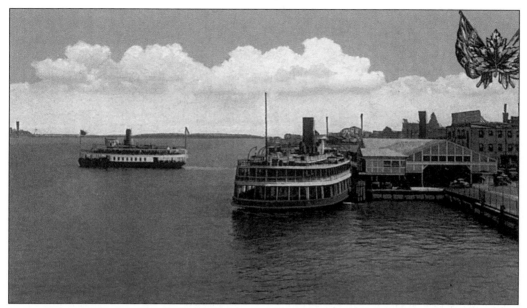

FERRY DOCK. The *Cadillac* is departing for Detroit from the Windsor passenger ferry dock. Another ferry is arriving at the dock. Beside the *Cadillac*, there were a number of other ferries including the *La Salle* and the *Excelsior*.

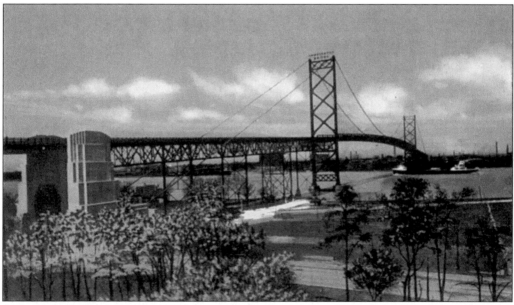

AMBASSADOR BRIDGE. The need for passenger ferries was eliminated when the Ambassador Bridge was built. It has a height of 152-feet above the river so boats have ample space to pass under it. While the main span is 1,850 feet, the total bridge length is 2 miles. This view is from Windsor to Detroit.

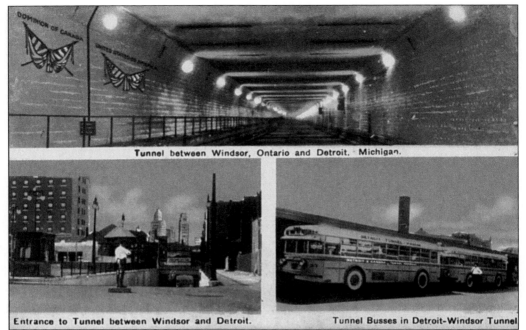

Tunnel between Windsor, Ontario and Detroit. Michigan.

Entrance to Tunnel between Windsor and Detroit.

Tunnel Busses in Detroit-Windsor Tunnel

AUTO TUNNEL. In addition to the bridge, a tunnel was built for automobiles and busses. The international boundary line is marked on the tunnel wall between the crossed flags of the United States and Canada. The entrance to the tunnel is shown on the postcard at Windsor.

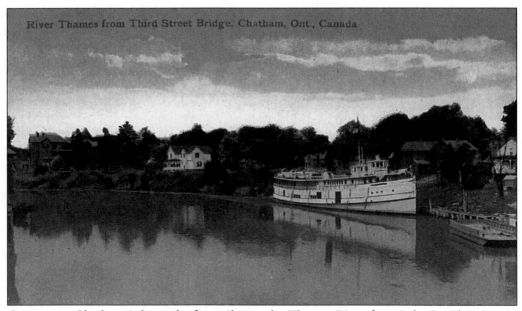

River Thames from Third Street Bridge, Chatham, Ont., Canada

CHATHAM. Chatham is located a few miles up the Thames River from Lake St. Clair. It is in the heart of an agricultural area. At the turn of the century, both passengers and farm products went on small steamers down the Thames to Lake St. Clair and the Detroit River to Windsor and other ports.

118

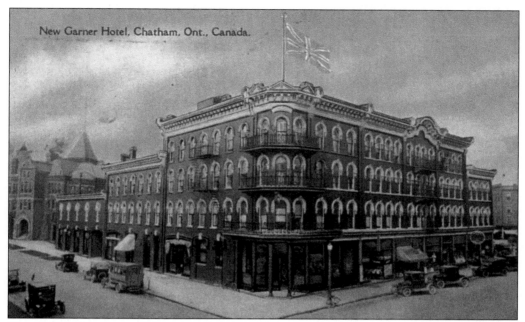

New Garner Hotel, Chatham, Ont., Canada.

HOTEL AT CHATHAM. This postcard was mailed in 1930. The cars suggest that the picture of the Garner Hotel was taken somewhat earlier. Today a pleasant time may be had visiting Chatham by car or by pleasure boat up the Thames River.

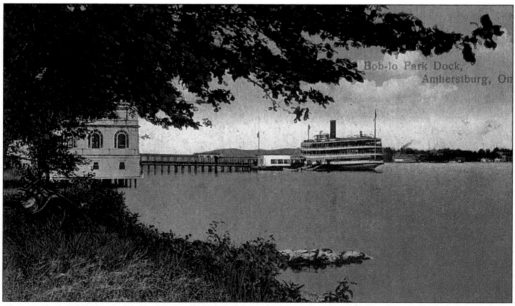

Bob-lo Park Dock, Amherstburg, On

AMHERSTBURG. Bob-lo Park was on an island just offshore from Amherstburg and 12-miles down river from Detroit. Boats ran regularly from Detroit to Bob-lo. Amherstburg's history includes being the site of Fort Malden, a British fort during the War of 1812. It was also a terminus on the Underground Railroad for slaves escaping from the United States prior to the Civil War.

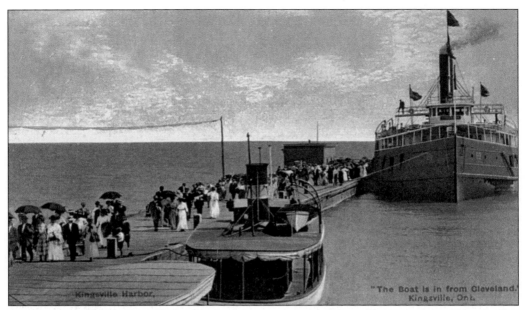

KINGSVILLE. The steamer *Forest City* is shown arriving at Kingsville en route to Detroit. For many years ferries to Leamington, Pelee Island, and Sandusky have originated at Kingsville. Most of Canada's South Shore is agricultural area without any large cities. Leamington is known as "Canada's Tomato Capital."

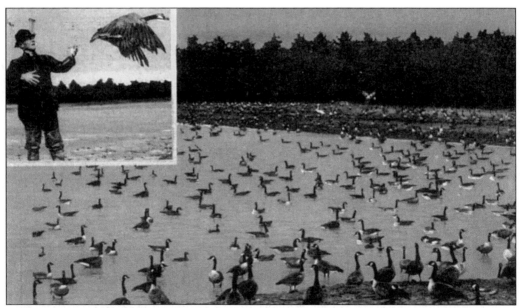

JACK MINER BIRD SANCTUARY. Early in the 20th century, Jack Miner (1865–1944), shown in upper left hand corner, established a sanctuary for migrating birds. In 1945 the Order of the British Empire was awarded "for the greatest achievement in conservation in the British Empire." His work served as a model for provincial and state bird sanctuaries around the lake.

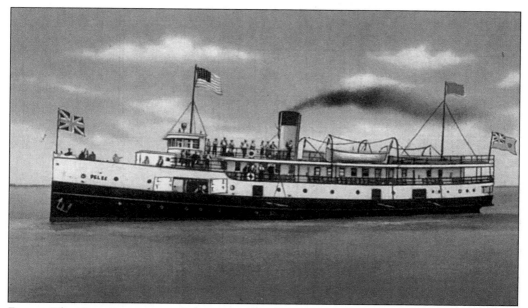

PELEE. The Canadian steamer *Pelee* ran weekly ferry service from Kingsville to Leamington, Pelee Island, and Sandusky from 1914 to 1936, and then from 1941 to 1960 she ran daily trips. In addition to passengers, she also carried freight including an annual cargo to Sandusky of turkeys, geese, ducks, and chickens just before Thanksgiving.

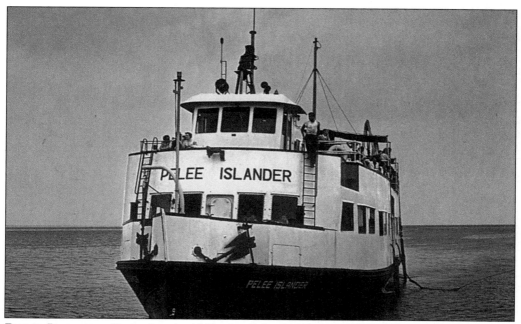

PELEE ISLANDER. Beginning in 1960, the *Pelee Islander* provided daily service during the summer season from Kingsville to Leamington, Pelee Island, and Sandusky. Pelee Island has maintained more of a rural character than other Lake Erie Islands.

PELEE ISLAND LIGHTHOUSE. Built in 1833, the Pelee Island Lighthouse was decommissioned in 1909. The conical limestone structure deteriorated over the years. In 2000 the lighthouse was restored and relit by the local historical society with grants from the Canadian government.

PELEE ISLAND CLUB. At 8 miles in length, Pelee is the largest of the Lake Erie islands. It is located just 3-miles north of the international boundary. Pictured is the Pelee Island Club built in the 1880s. Its membership has included a number of wealthy people from both sides of the lake.

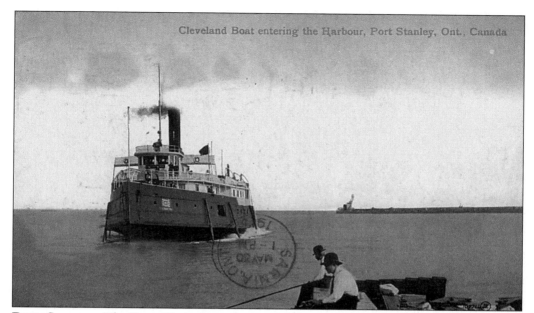

Cleveland Boat entering the Harbour, Port Stanley, Ont., Canada

PORT STANLEY. The *Forest City* is shown here arriving at Port Stanley about 1915. At the mouth of Kettle Creek, Port Stanley has long been a major port for shipping agricultural products and for receiving coal and oil. It has been a popular resort for most of the 20th century.

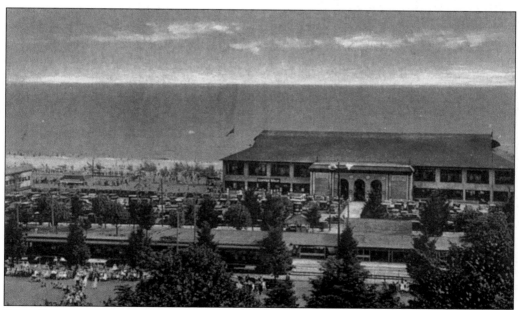

PORT STANLEY. An attraction of Port Stanley has been its dance pavilion, shown here in 1930. Crowds are shown at the beach at the top of the picture and at the ball field at lower left.

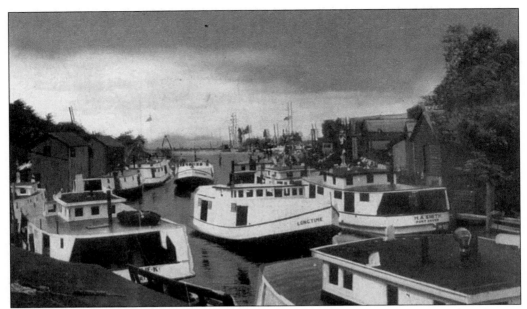

PORT DOVER. For more than a century, Port Dover on Long Point Bay was homeport for one of Lake Erie's largest fishing fleets. In 2001 it is the center for Canada's offshore drilling for natural gas. At present the United States does not permit offshore drilling in its part of the lake.

PORT ROWAN. Tourists are attracted to Port Rowan, located on the bay and formed by the 20-mile long peninsula known as Long Point. Before the days of accurate weather forecasts, radio, and radar, about 125 boats sank off Long Point.

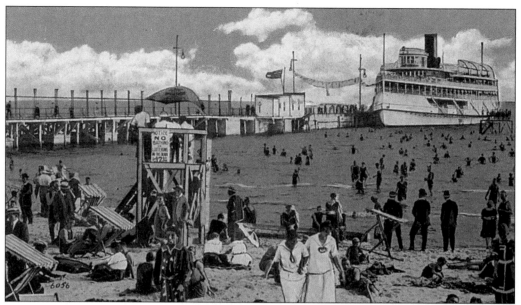

CRYSTAL BEACH. For nearly a century, beginning in the late 1800s, crowds came from Buffalo and nearby Ontario towns to the resort at Crystal Beach. In 2001 the beach and some cottages remain but the dock and amusements are gone.

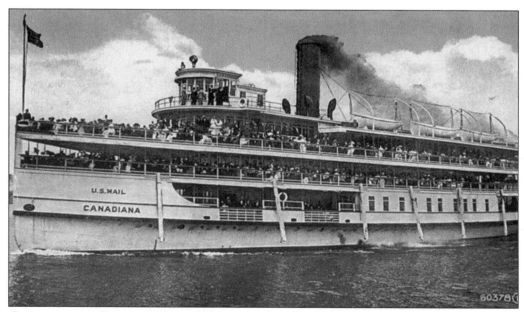

CANADIANA AT CRYSTAL BEACH. With a capacity of 3,500 passengers, the *Canadiana* brought crowds to enjoy Crystal Beach. It is just 10 miles from Buffalo to Crystal Beach. Built in 1910, the *Canadiana* eventually became a restaurant at Cleveland.

WELLAND CANAL. William H. Merritt is honored by a park named for him in Welland. He conceived the idea of a series of locks in a canal that would make it possible to bypass Niagara Falls and allow boats to go from Lake Erie to Lake Ontario. The first canal was completed in 1829 and it has been enlarged and slightly relocated three times. Both sides of a lift bridge over the canal are seen beyond the gazebo.

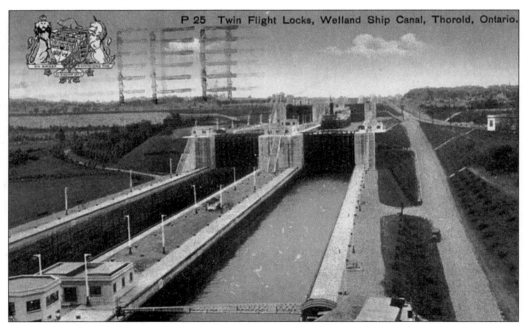

P 25 Twin Flight Locks, Welland Ship Canal, Thorold, Ontario.

WELLAND CANAL. Boats enter the Welland Canal at Port Colborne and proceed through eight locks before reaching Lake Ontario. Each lock has an average lift of just over 46 feet. This 1930s picture shows a boat in the lock at Thorold. It gives a perspective on how far boats are raised or lowered at each lock.

BIBLIOGRAPHY

Bowen, Dana T. *Lore of the Lakes.* Cleveland, OH: Freshwater Press, Inc., 1940.

Bowen, Dana T. *Memories of the Lakes.* Daytona Beach, FL: Dana T. Bowen Publisher, 1946.

Boyer, Dwight. *Ships and Men of the Great Lakes.* New York: Dodd, Mead & Co., 1977

Francis, David and Diane. *Cedar Point, Queen of American Watering Places.* Canton, Ohio: Daring Books, 1988.

Hatcher, Harlan. *Lake Erie.* New York: Bobbs - Merrill Co., 1945.

Hatcher, Harlan, and Walter, Erich A. *A Pictorial History of the Great Lakes.* New York: Bonanza Books, 1963.

Havighurst, Walter, editor. *The Great Lakes Reader.* New York: Macmillan Co., 1966.

LeLievre, Roger, editor. *Know Your Ships 2000.* Sault Ste. Marie, MI: Marine Publishing Co., 2000.

Marchetti, Donna. *Around the Shores of Lake Erie.* Saginaw, MI: Glovebox Guide Books of America, 1998.

Neidecker, Betty. *The Marblehead Lighthouse: Lake Erie's Eternal Flame.* Self Published, 1995.

Oleszewski, Wes. *Great Lakes Lighthouses.* Gwinn, MI: Avery Color Studios, 1998.

Wendt, Gordon. *In the Wake of Walk-in-the-Water.* Sandusky, OH: Commercial Printing Co., 1984.

INDEX OF BOATS